Flowers De'Art

D. L. De McClung

Copyright © 2017 by D. L. De McClung

All rights reserved.

ISBN-10: 1546856099
ISBN-13: 978-1546856092

Other Works by D. L. De McClung

Words In A Row: Book One
(The Early Poems)

The Official Website of the Artist
deldemcclung.com

De McClung on FineArtAmerica.com
de-mcclung.pixels.com

De McClung's Podcast
spreaker.com/show/de-mcclungs-art-ra-monologs

<O>

Re'el De'el Books
~MCO~
McClung Originals
Eye Demon Studios
Deldeli Los Festus on Teverbaugh
Worthington, WV 26591
America

DEDICATION

To
Lilo

INTRODUCTION

Around my house there are flowers
In the season when flowers bloom
Some are wild and grow naturally
And some from seeds that I sow
They bring me joy and happiness
These wonders of botany
These yellow ones and red ones
The names of some I know
Like daisies and chrysanthemums
And dandelions too
I love them and water them
And give good care when due
And look upon them with gratitude
For all the joy they bring
To me and Lilo too
And so I make this book
A little work of love
To celebrate and show
A few blossoms and blooms
That in wondrous beauty grow
Around my humble home

May these pictures herein I've shown
Bring you joy and make you smile
As surely as they do me
If only for a while

As flowers tend to fade
I can only preserve them here
And hope this little book
Shows how much I hold them dear
For without these flowery things
So much in life be lost
Like honey for the bees
And nectar for butterflies
And all their beauty brings

I'm sharing them with you
As I'm inclined to do
This little book of flowers
And I hope you like them too

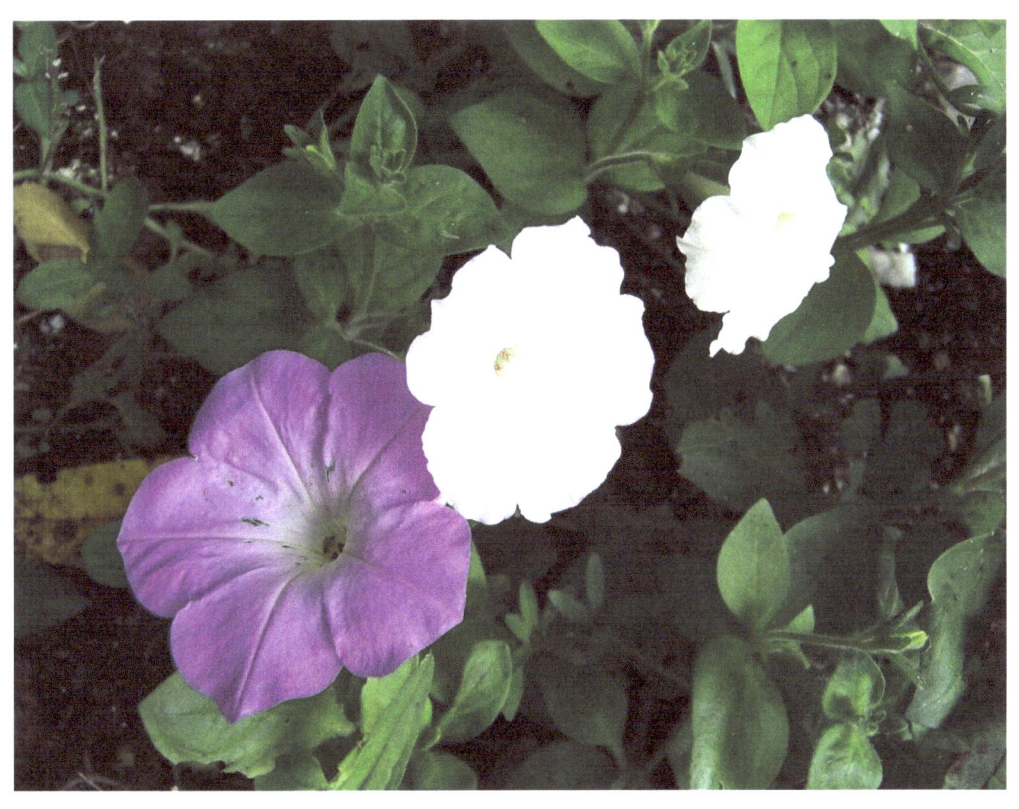

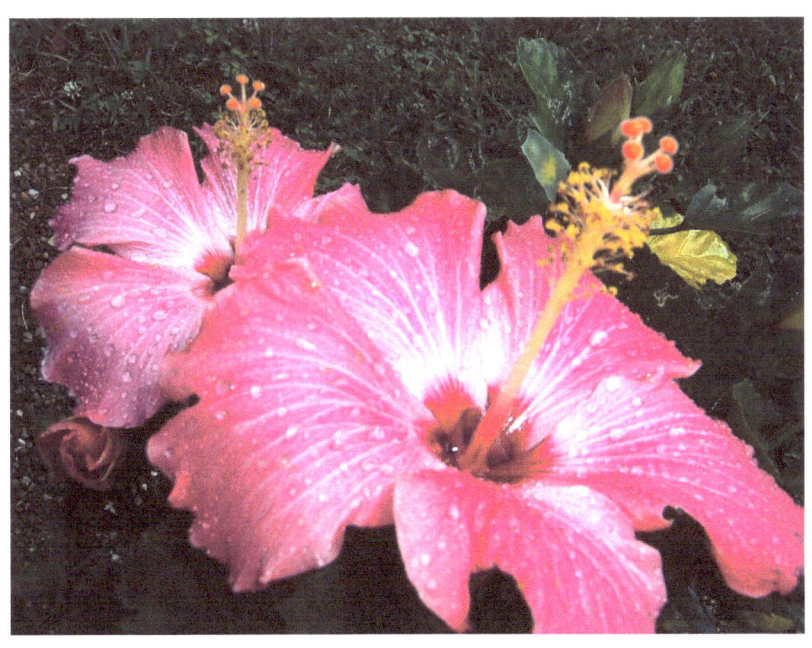

My flower my flower
You gorgeous thing
I've been waiting all Winter
For the coming of Spring

So you would arrive
And bring joy to my eyes
And lift up my spirit
That Winter denies

The snow is melted away
And the Spring rains renew
All that was sleeping
And awakens anew

The trees and the plants
And again they will grow
Everything will turn green
As the March winds blow

And April showers refresh
And wash Winter away
And make ready for Summer
During that long month of May

And June will arrive
And the flowers will bloom
And brighten the day
And put away Winter's gloom

If ever there was
A favorite time of the year
I think it is Spring
And finally it's here

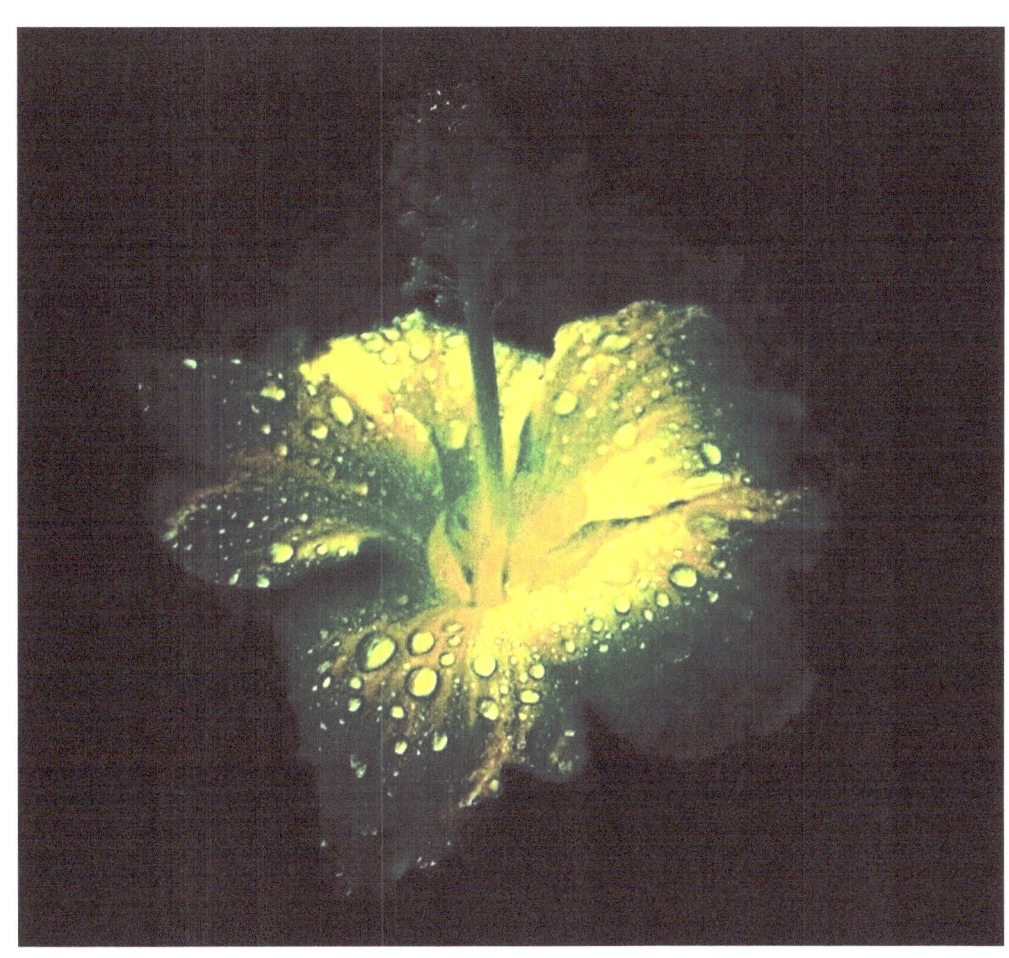

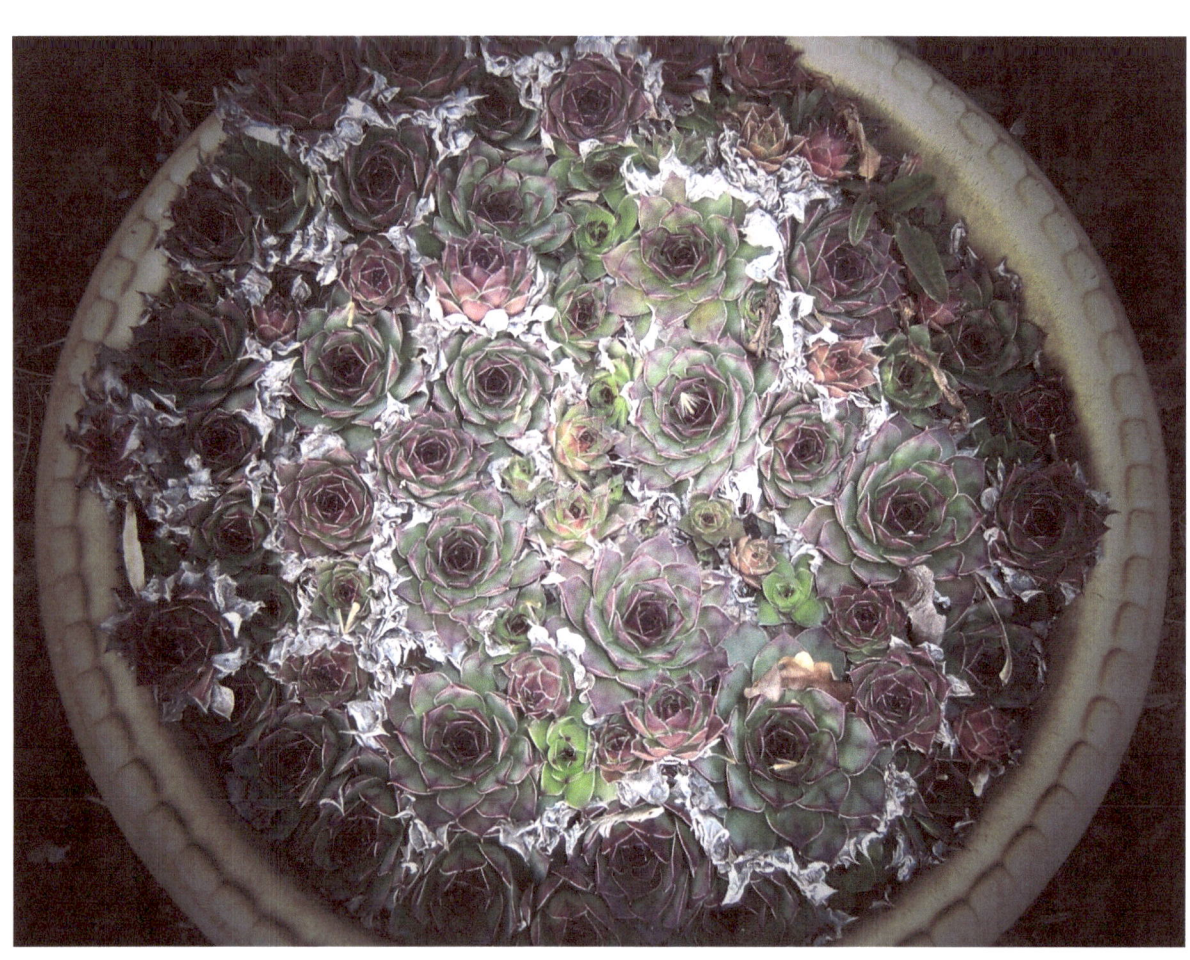

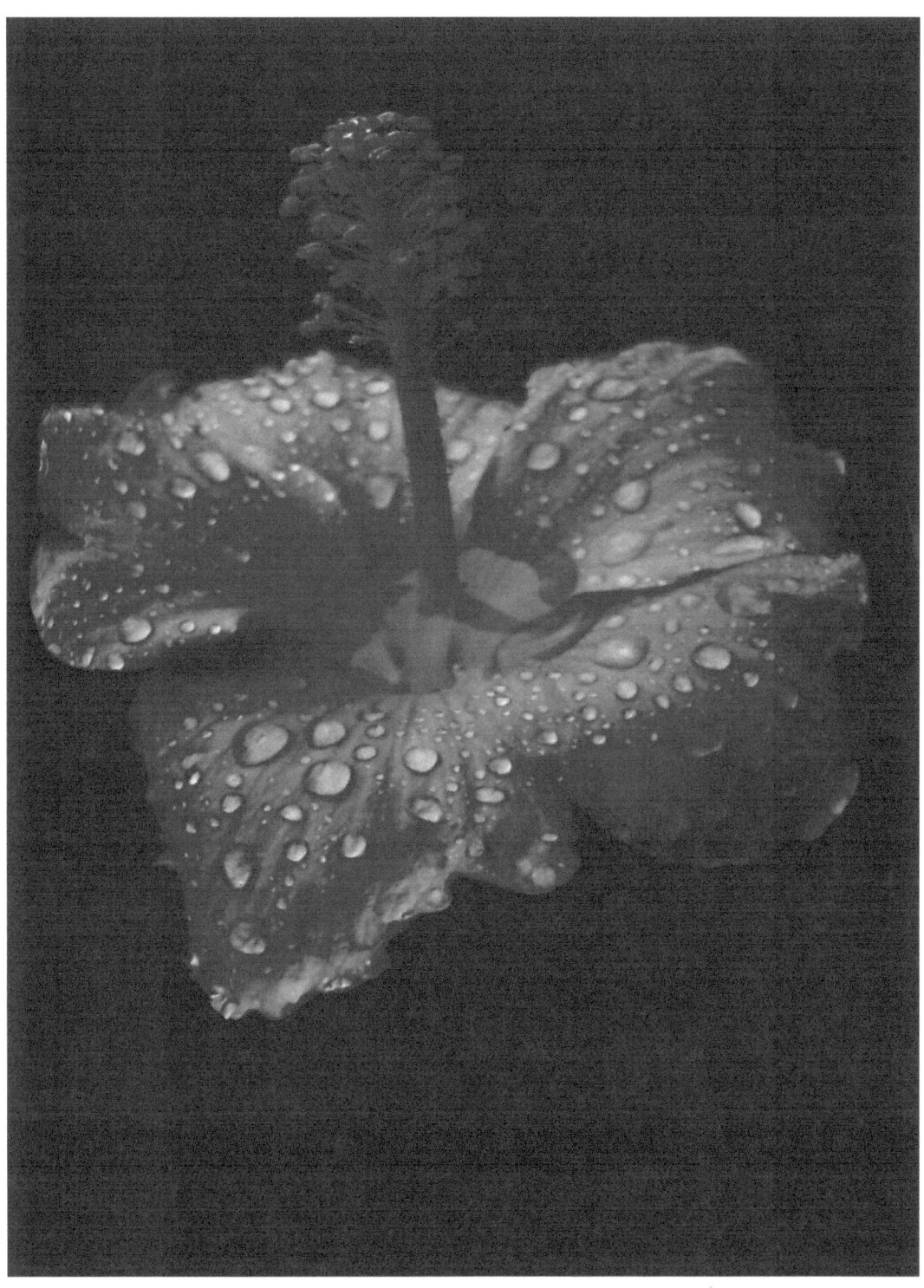

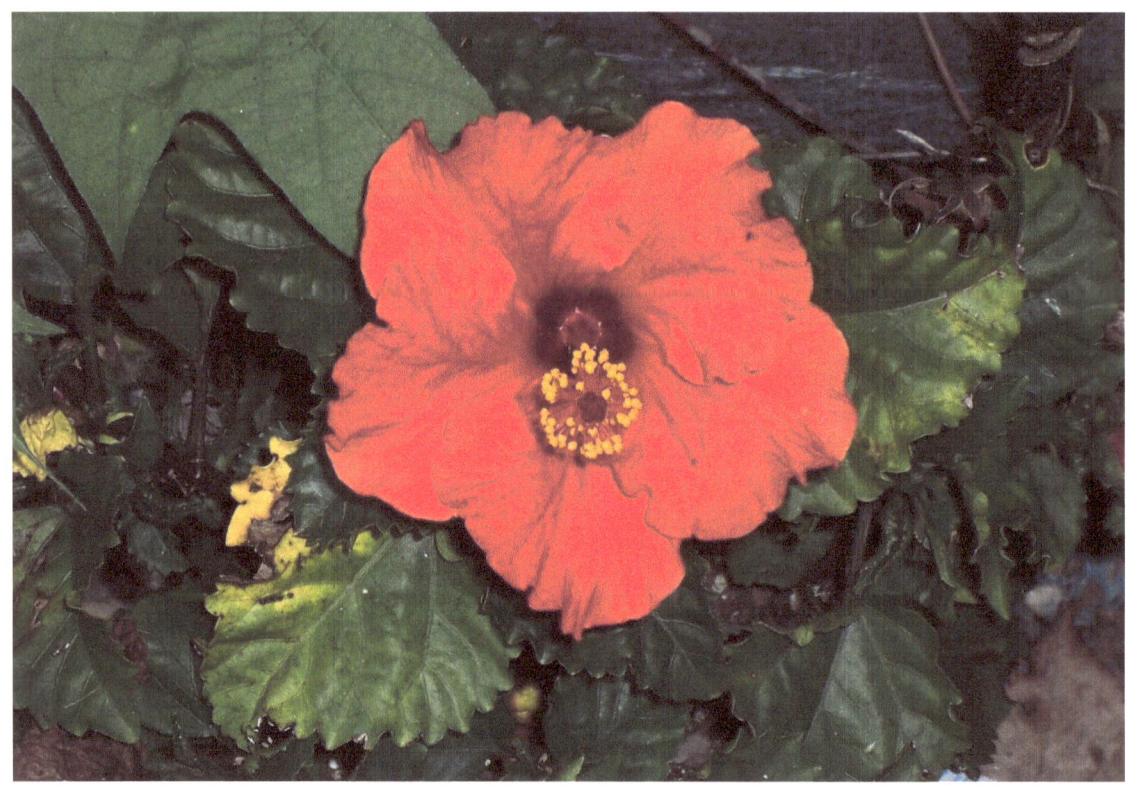

A flower, a flower
A sight to behold
A Daisy, a Rose
A Tulip, or Marigold
A bloom for the eye
A blossom to see
Nectar for butterflies
And the hummingbird or the bee
And always remember
However busy you are
Take the time to pause
And smell the Roses you see
Take time to enjoy
What Nature supplies
A feast for your soul
A sight for your eyes

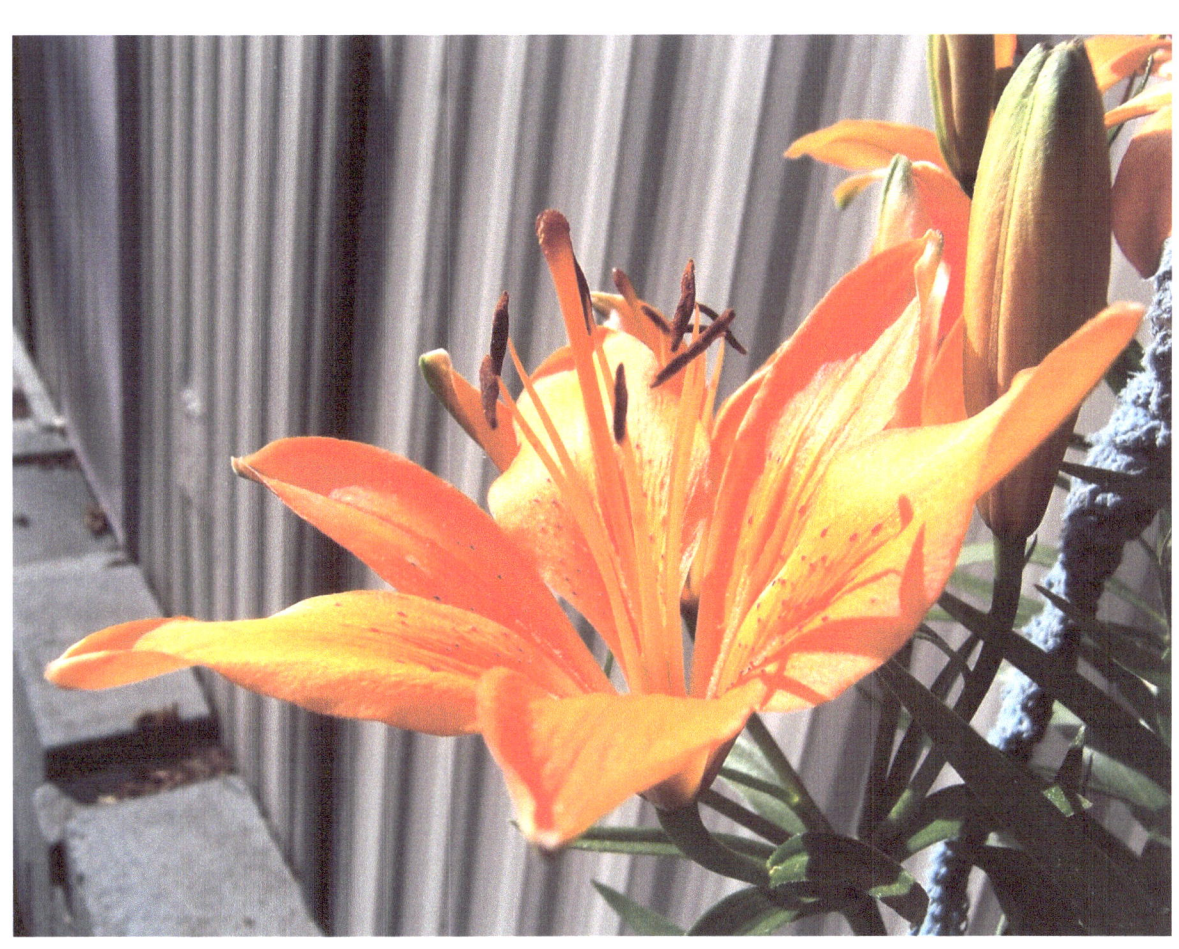

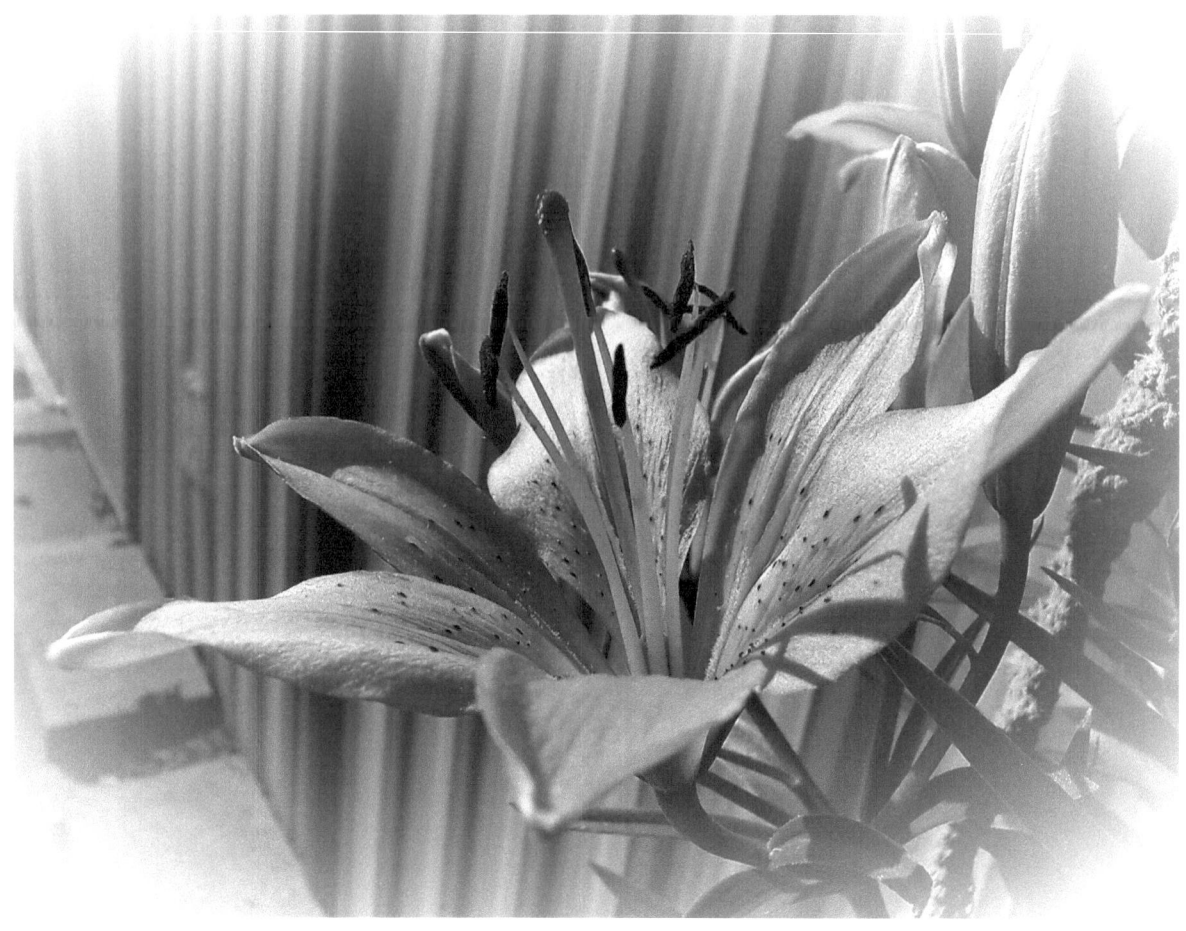

What can I say
You don't already know
About the beauty of flowers
And the seeds that they sow
In the Spring they come forth
And brighten up our day
The flowers of Spring
During April and May
And all Summer long
They bring joy our way
Whether in gardens
Or a lovely bouquet

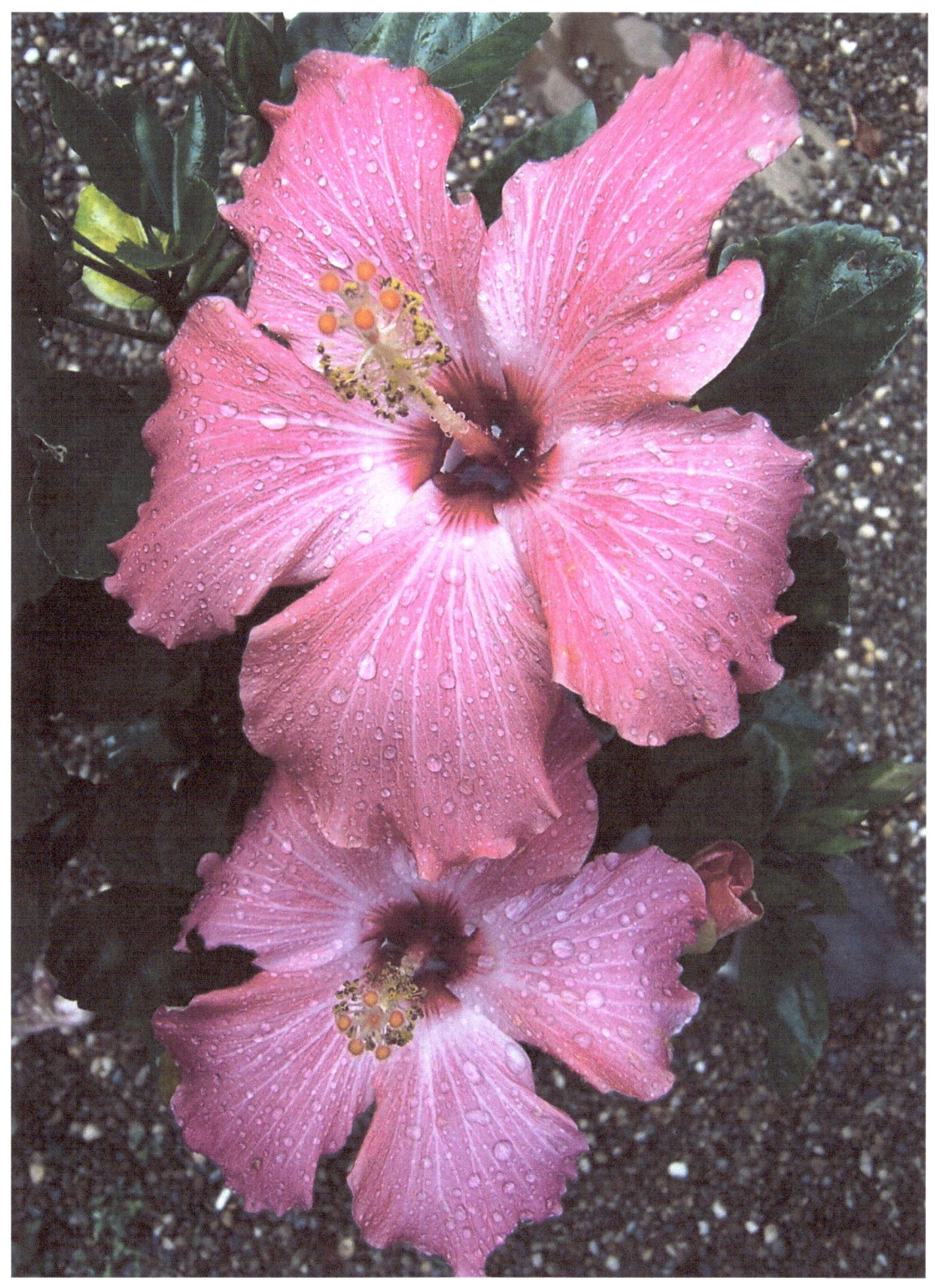

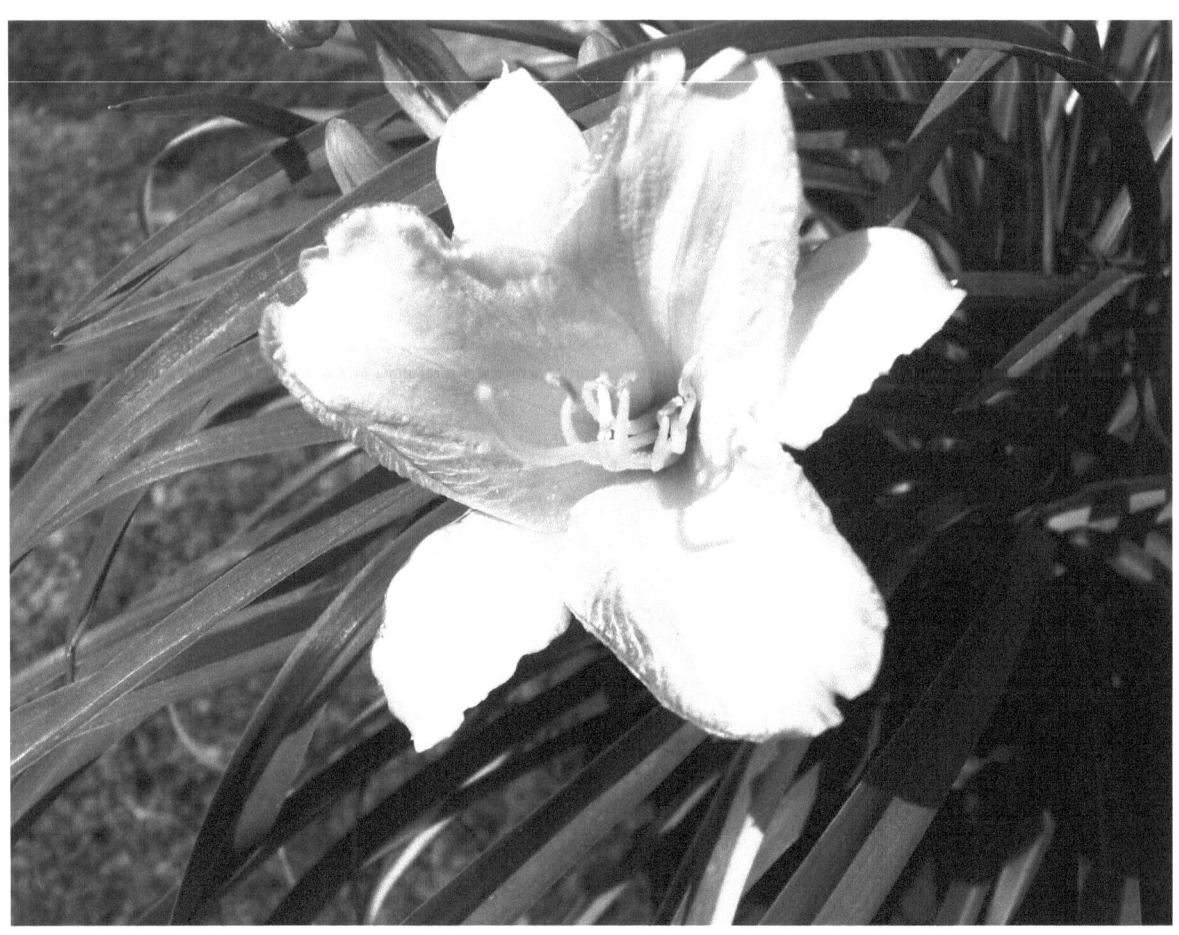

A flower is a wonderful thing
There's nothing to compare
Those delicate and fragile things
Grow about most every where

And in the spring they open up
Adding fragrance to the air
And spreading pollen in the breeze
Causing allergies to flare

And though we could complain
Though it does no good
I wouldn't change a thing
Even if I could

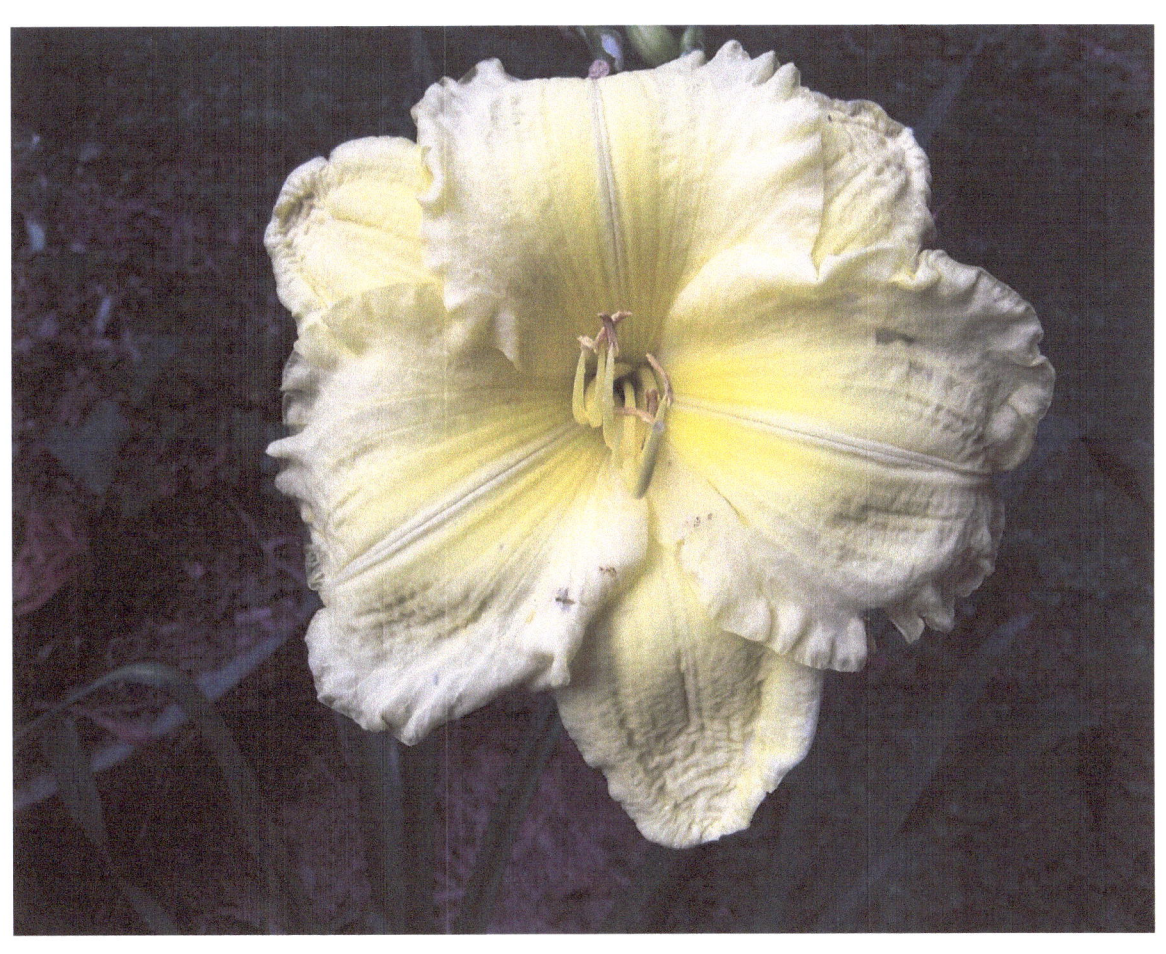

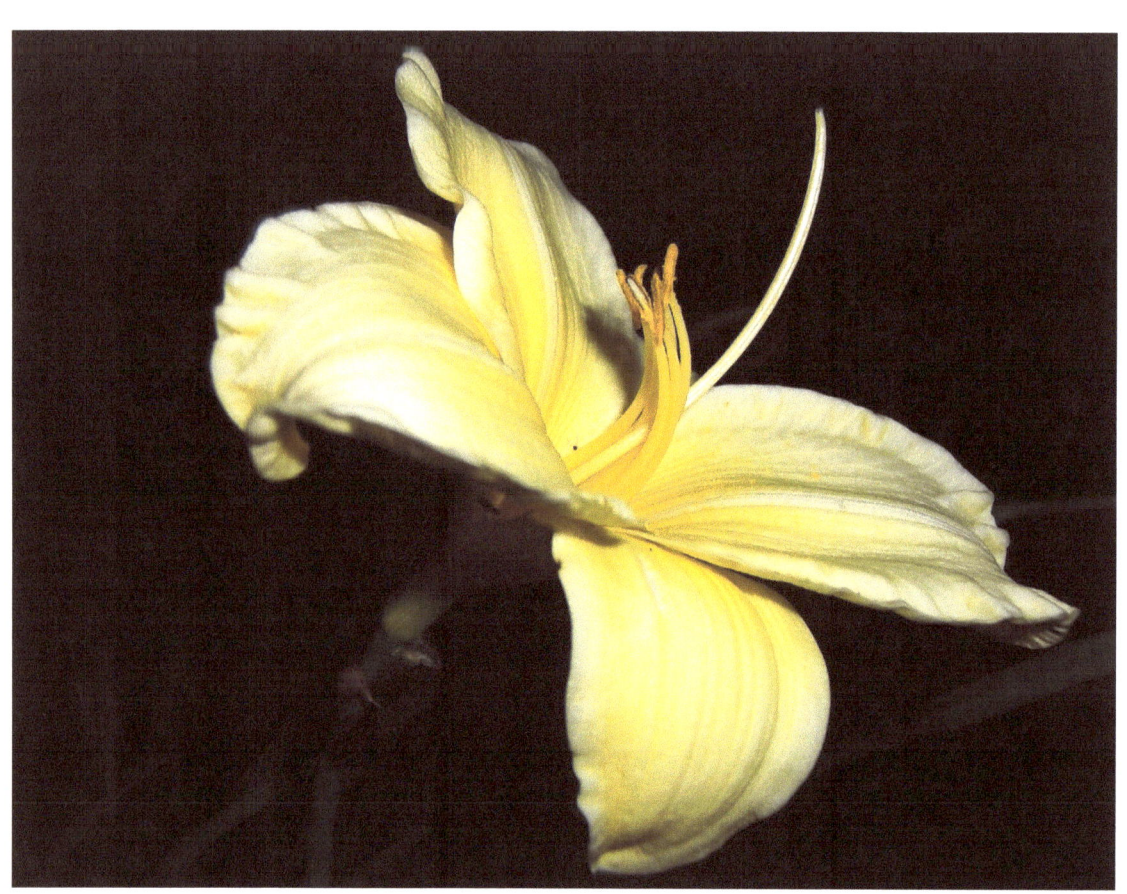

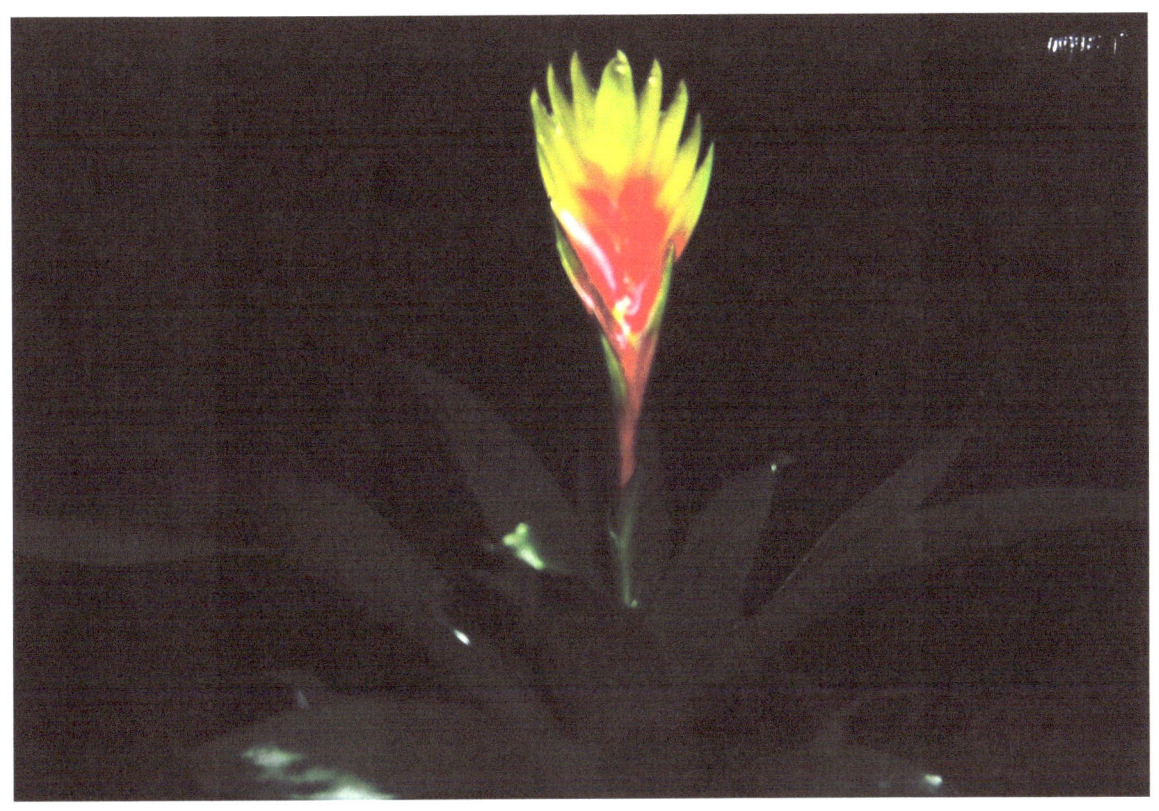

**Flowers come in oddly shapes
And varieties of form
Some are freaky like
While others are uniform**

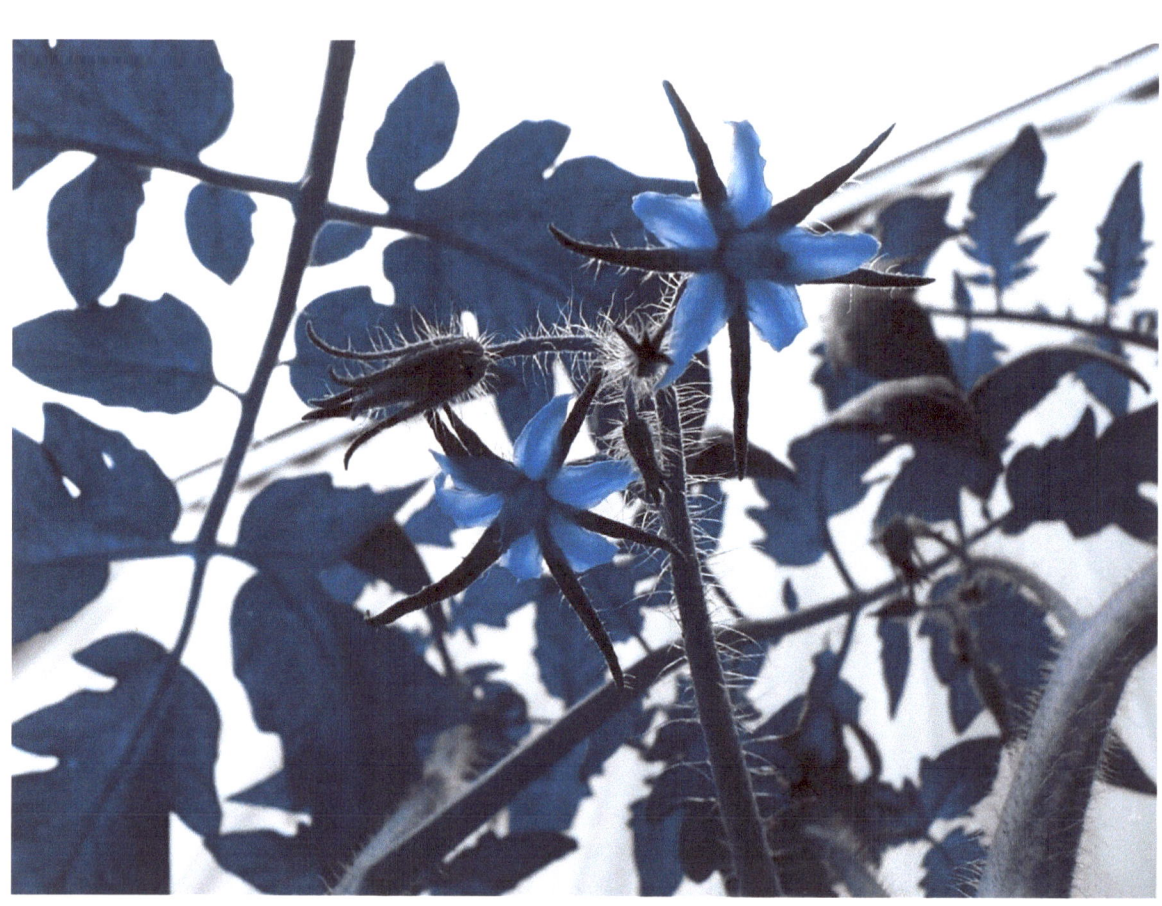

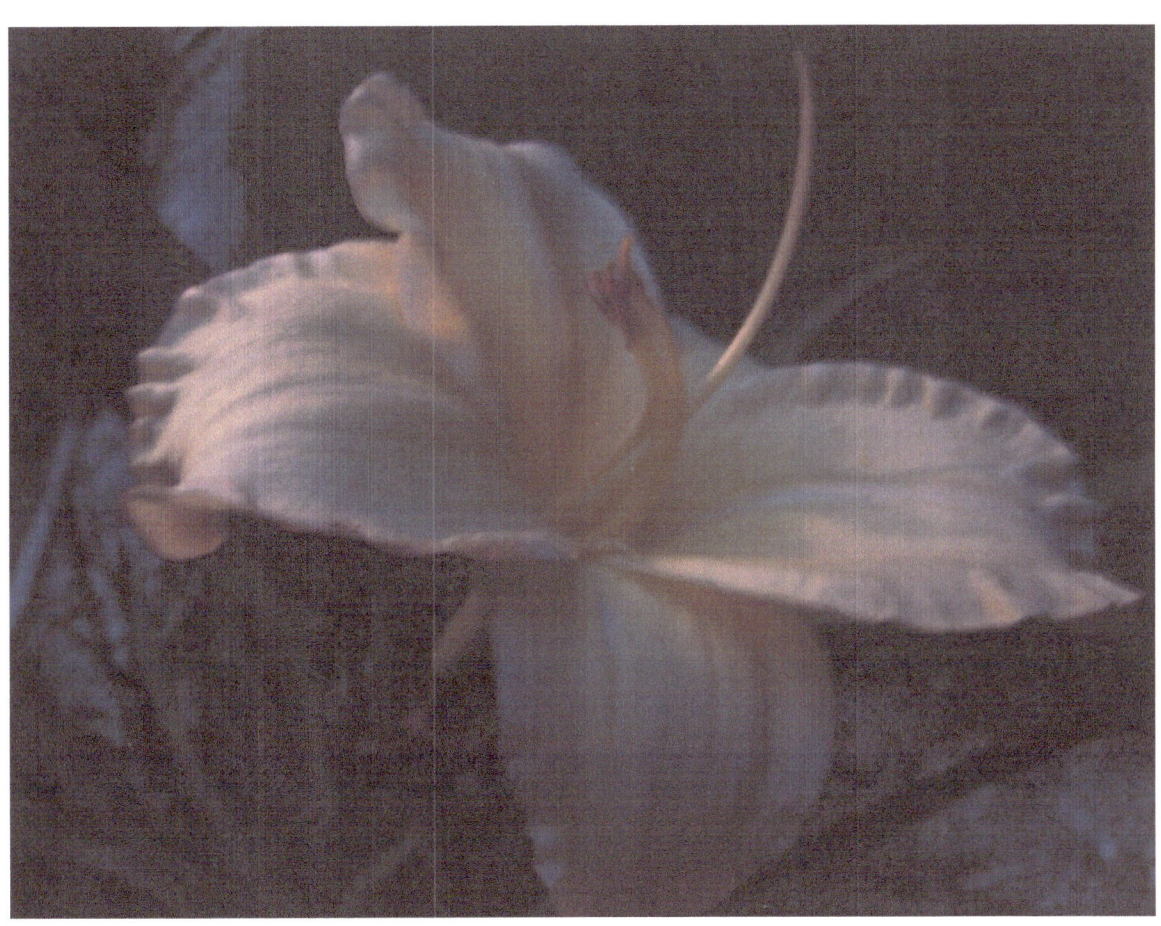

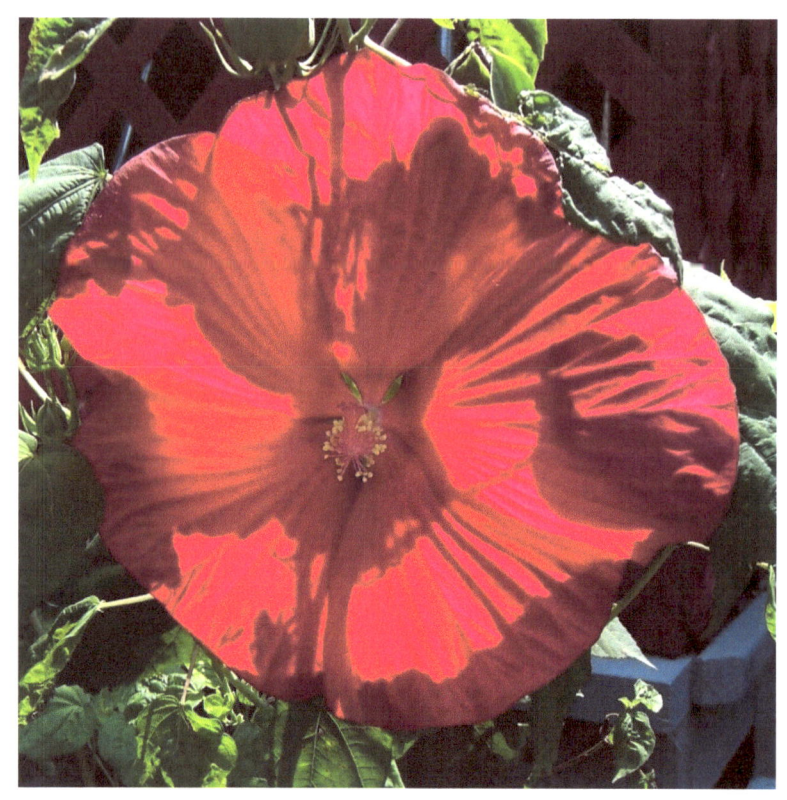

Some flowers are red
Some flowers are blue
Some come in pink
And yellow too

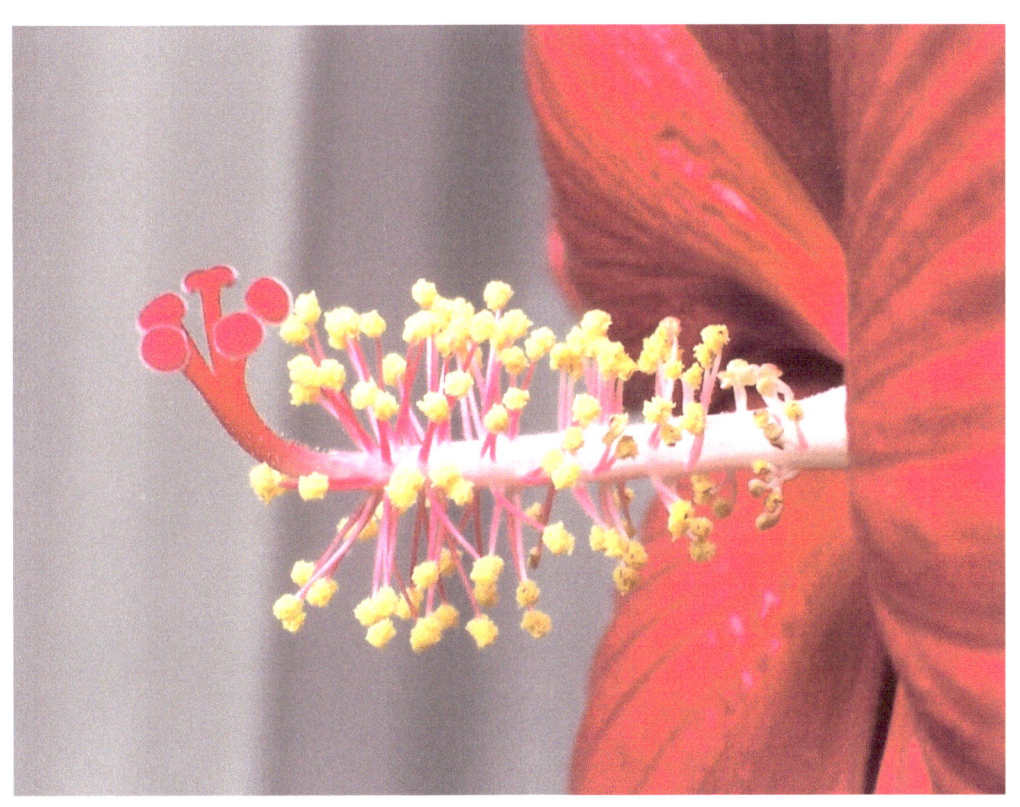

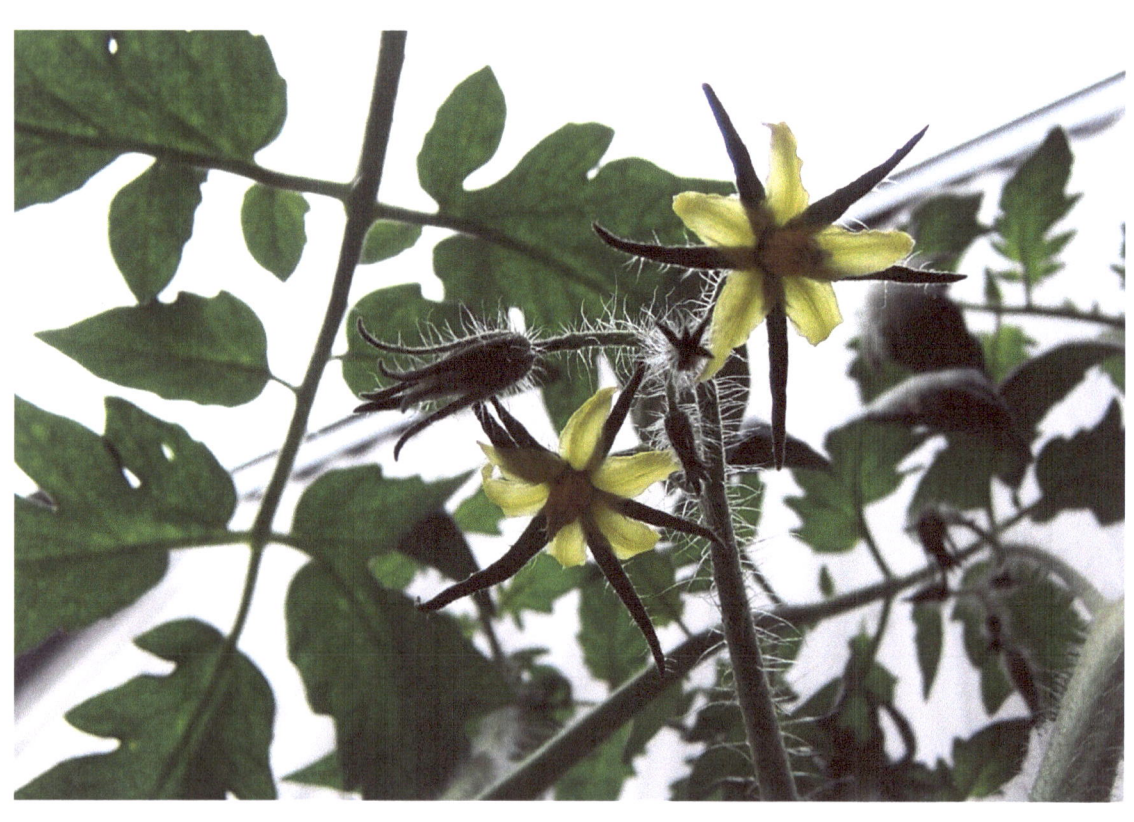

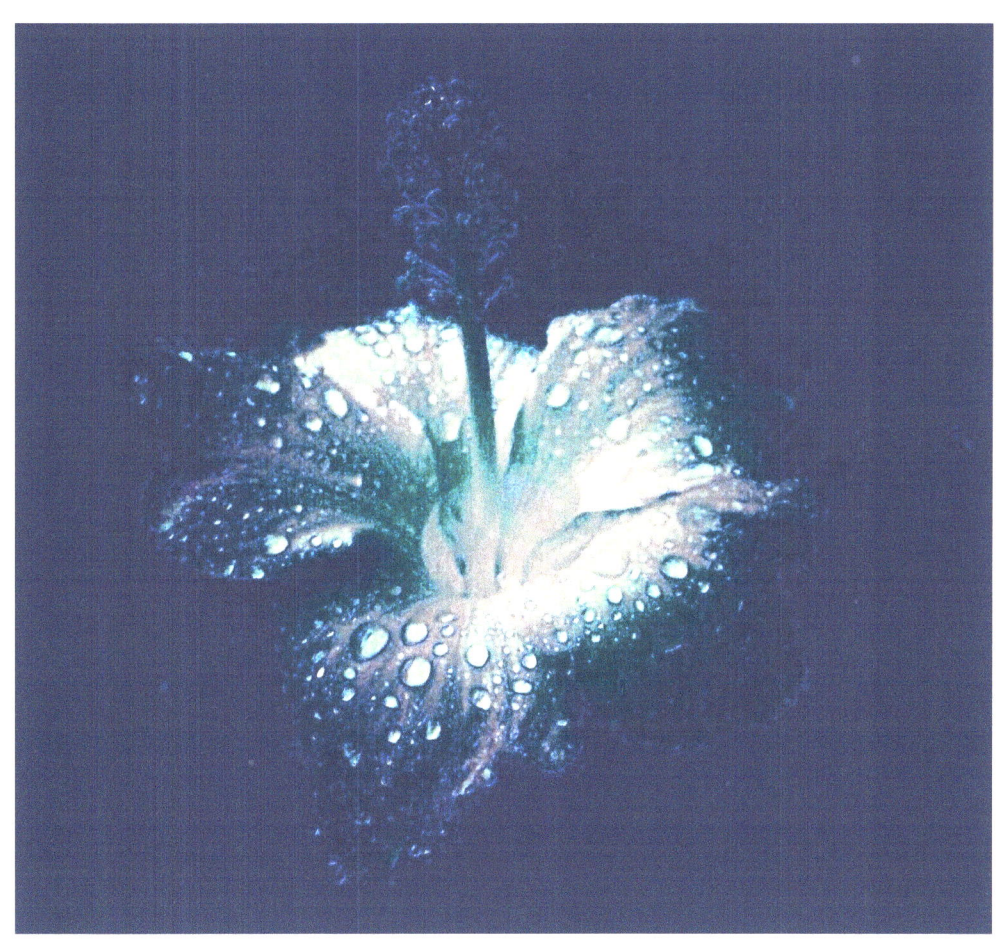

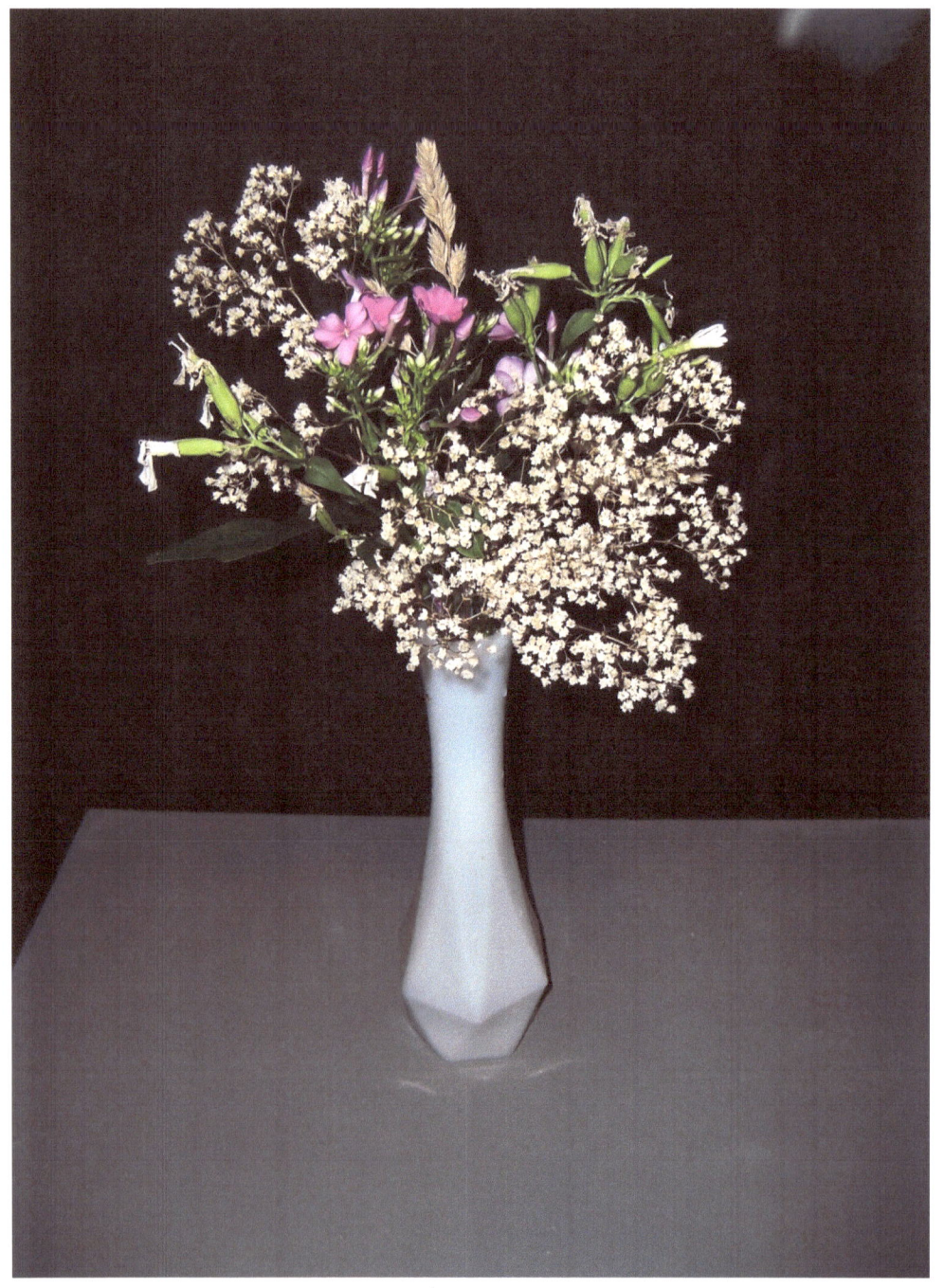

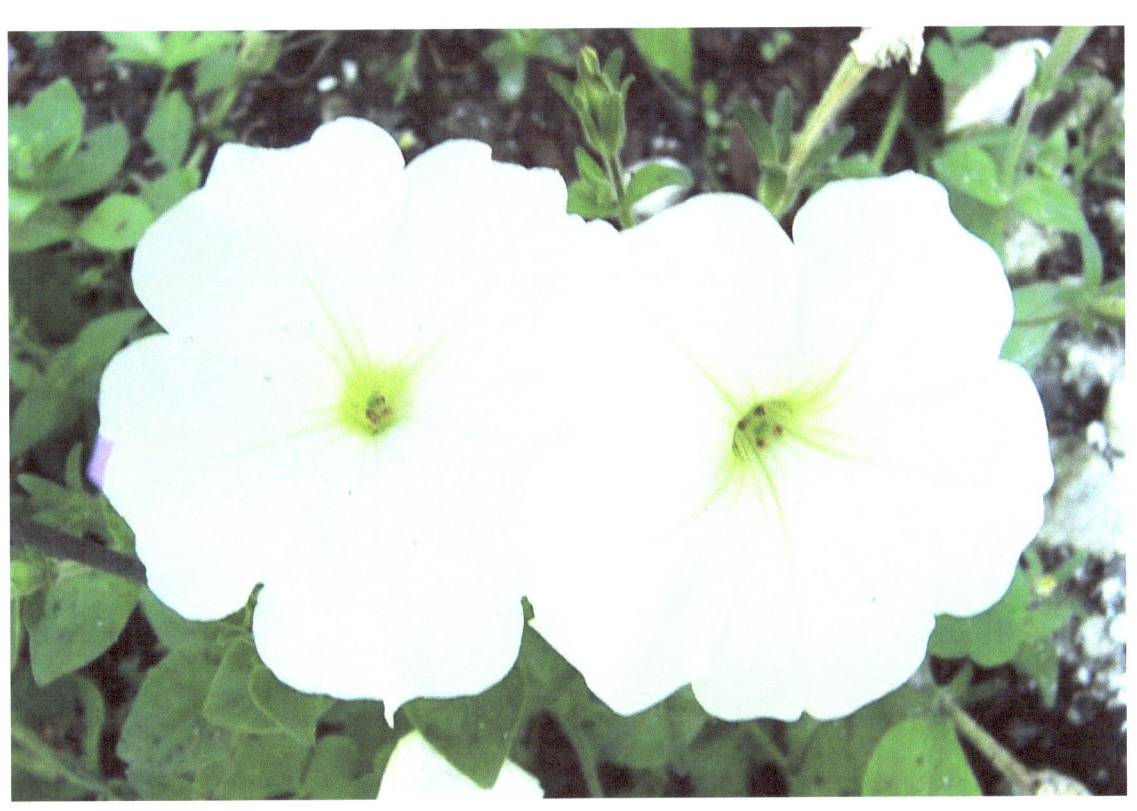

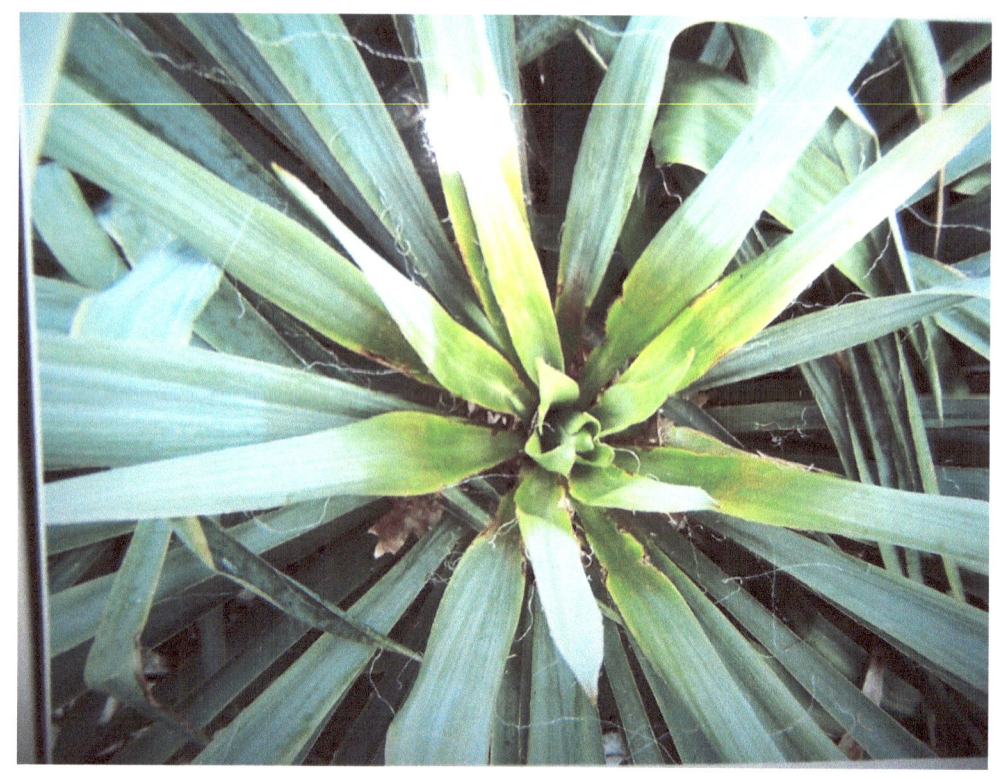

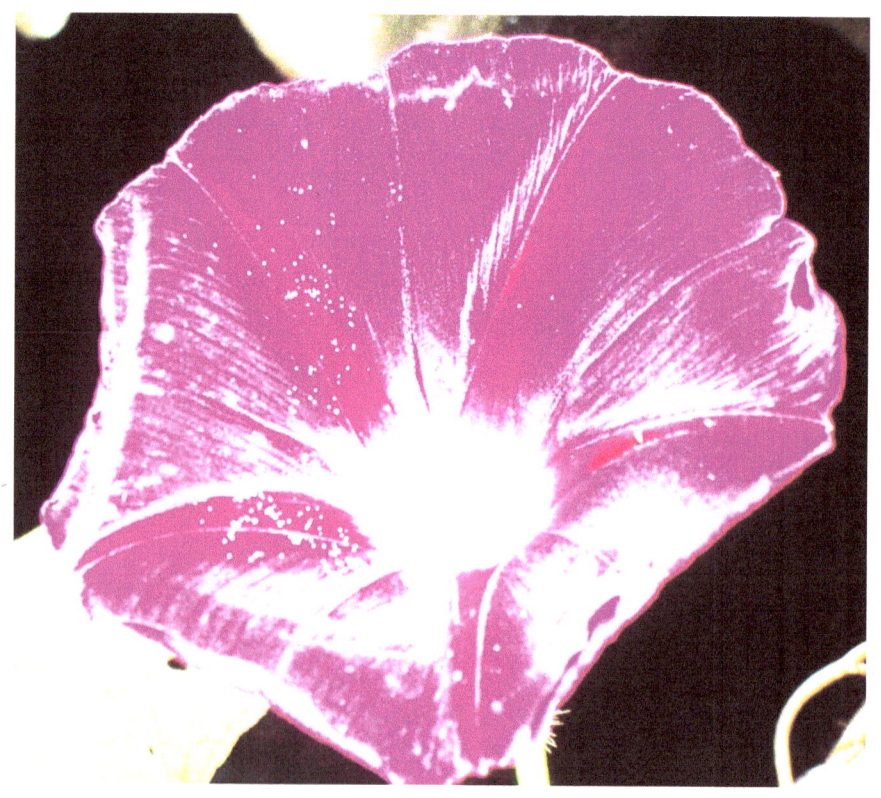

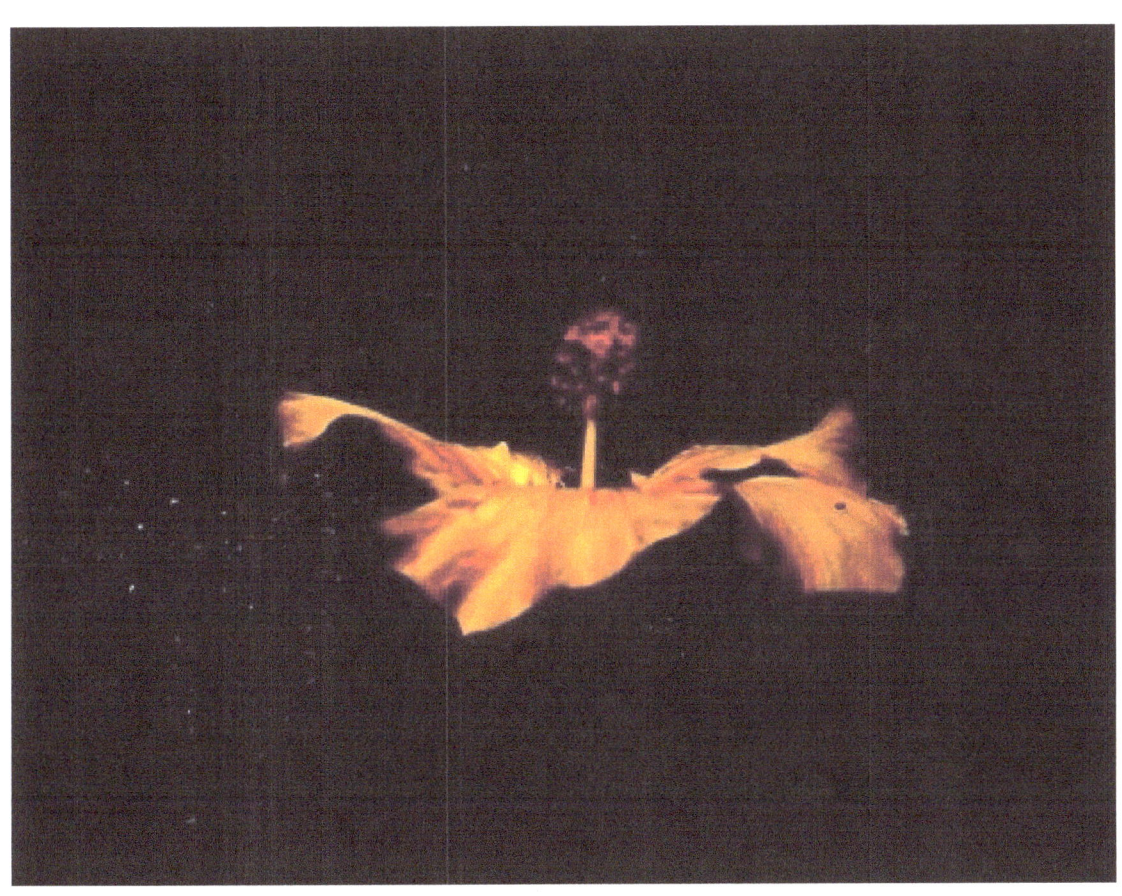

**A flower is a thing
With beauty and delight
This one is in the sky
Glowing in the night**

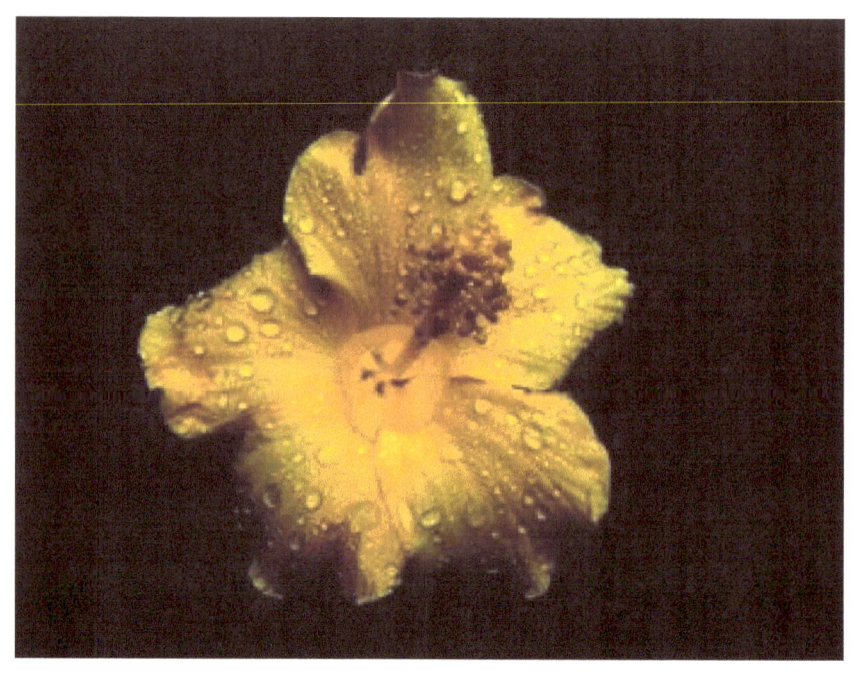

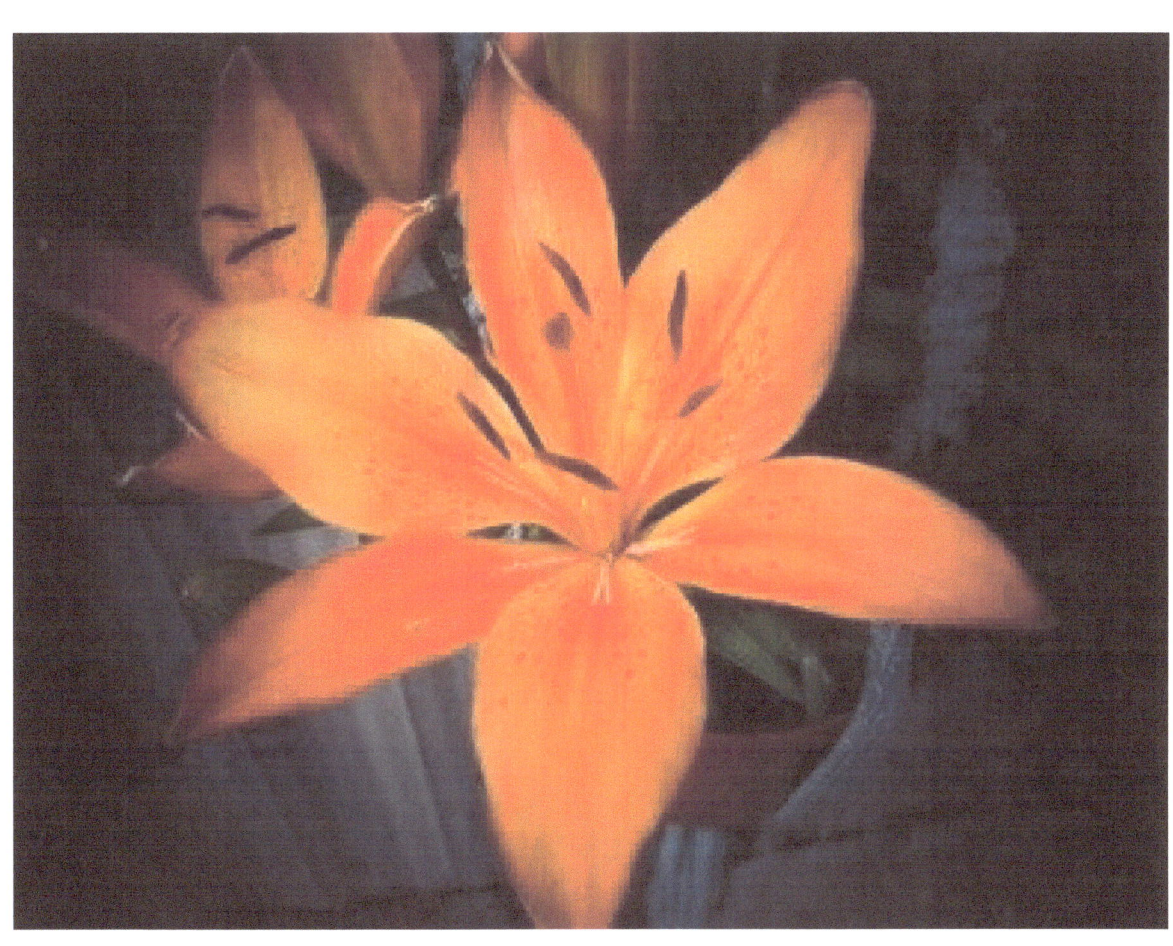

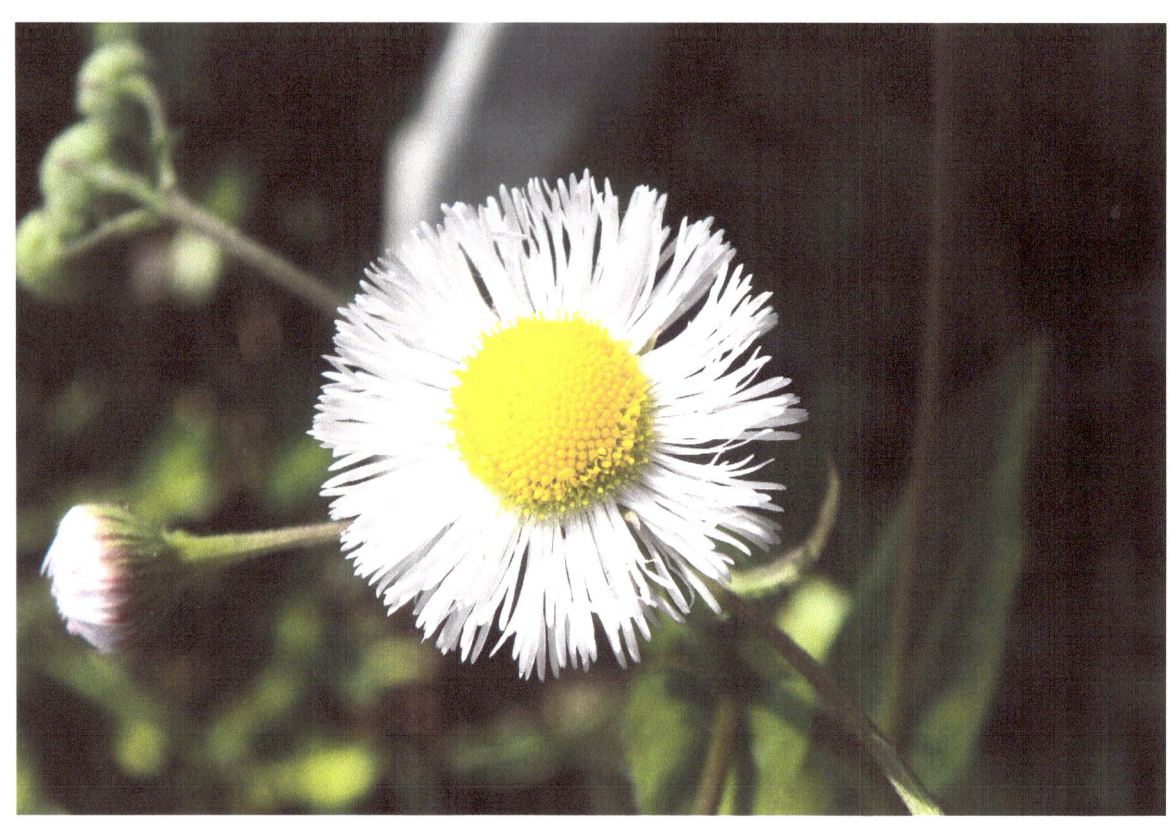

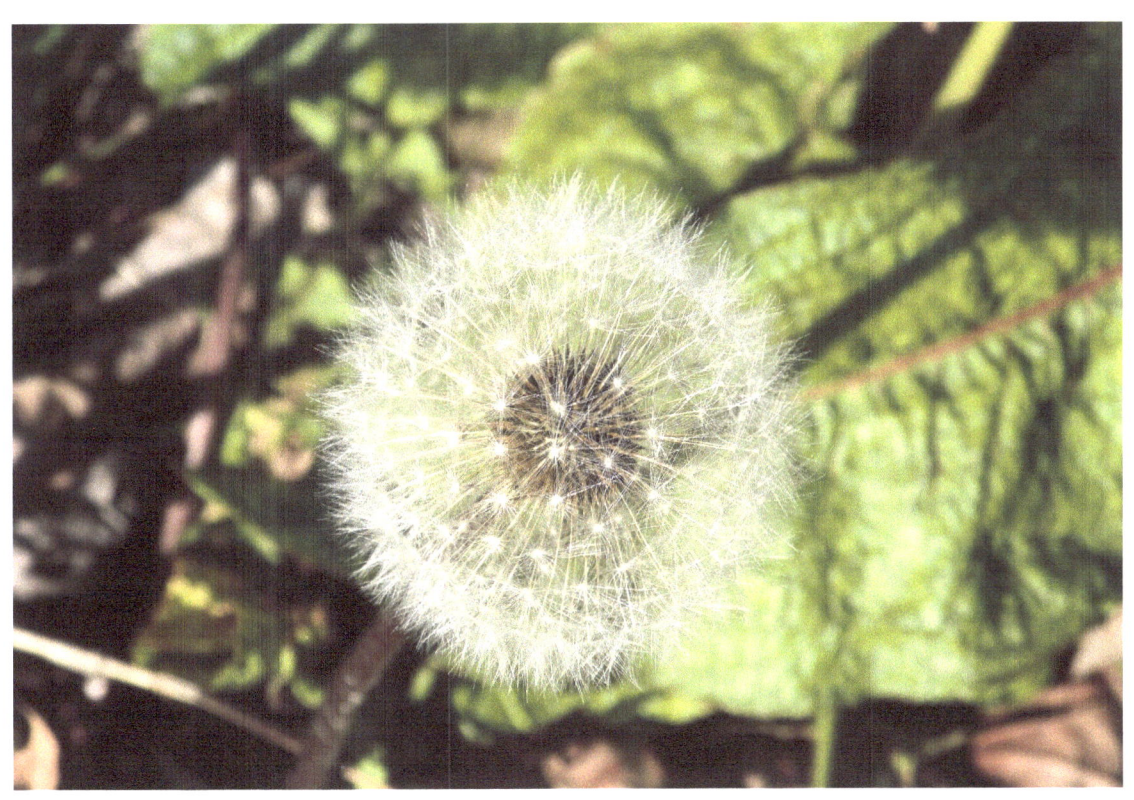

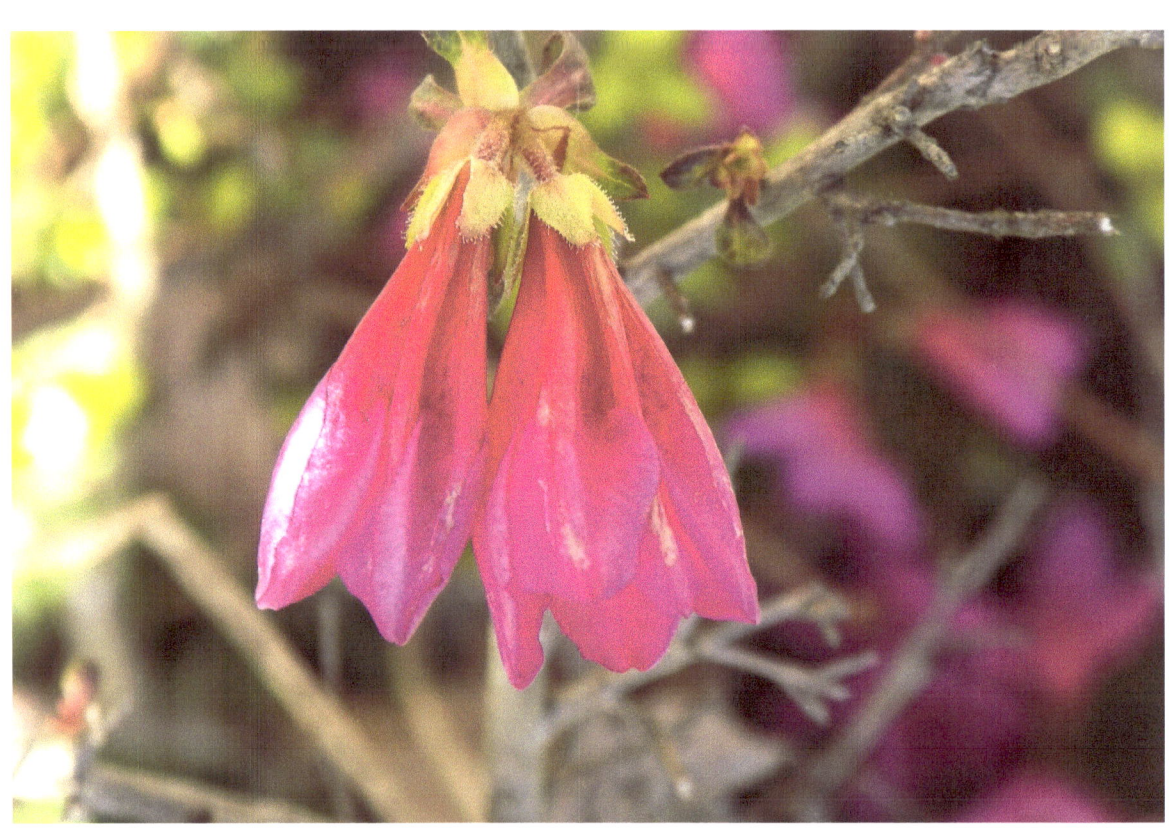

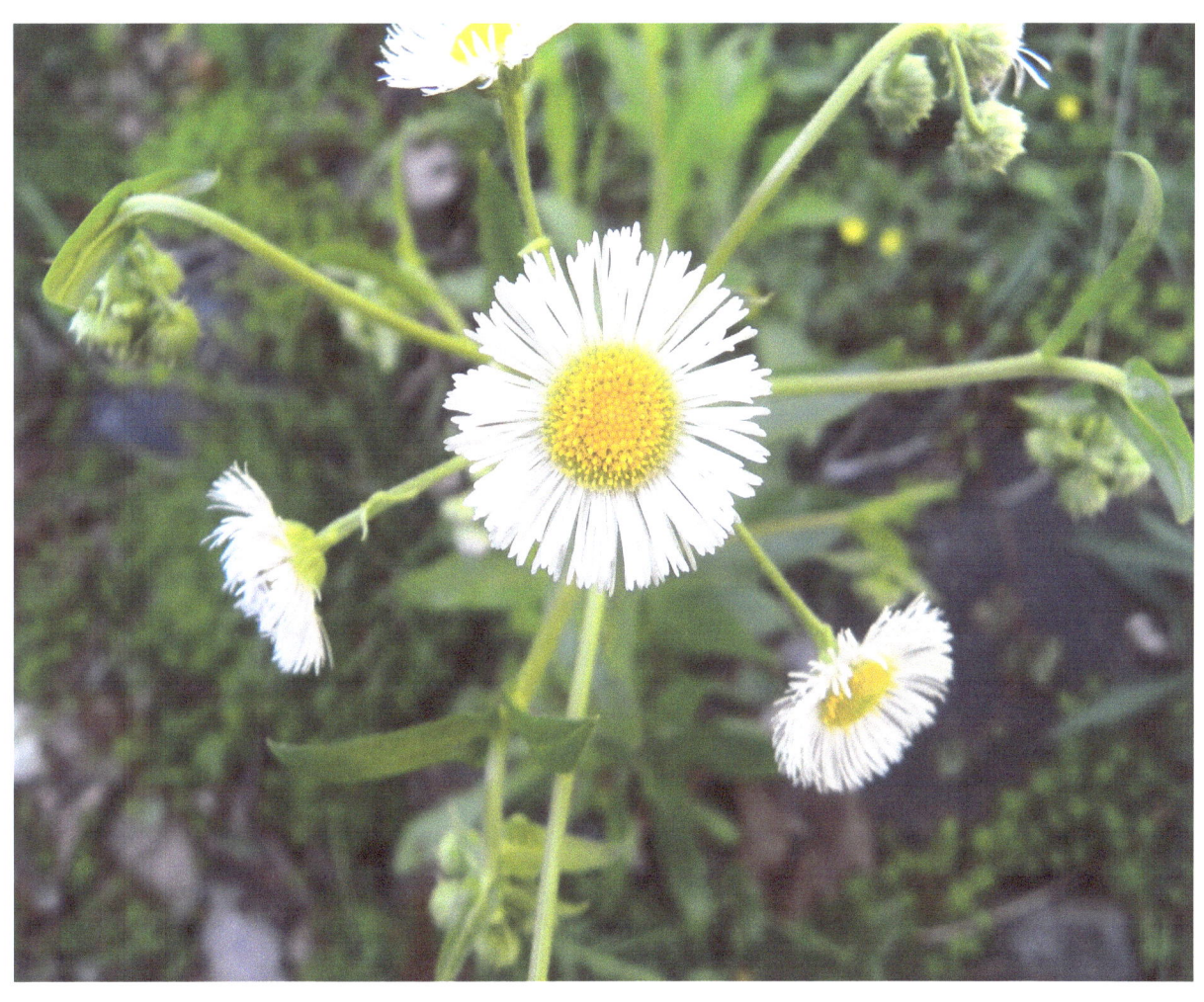

**A daisy is a cheery thing
It can always make me smile
It has a simple magic
And the power to beguile**

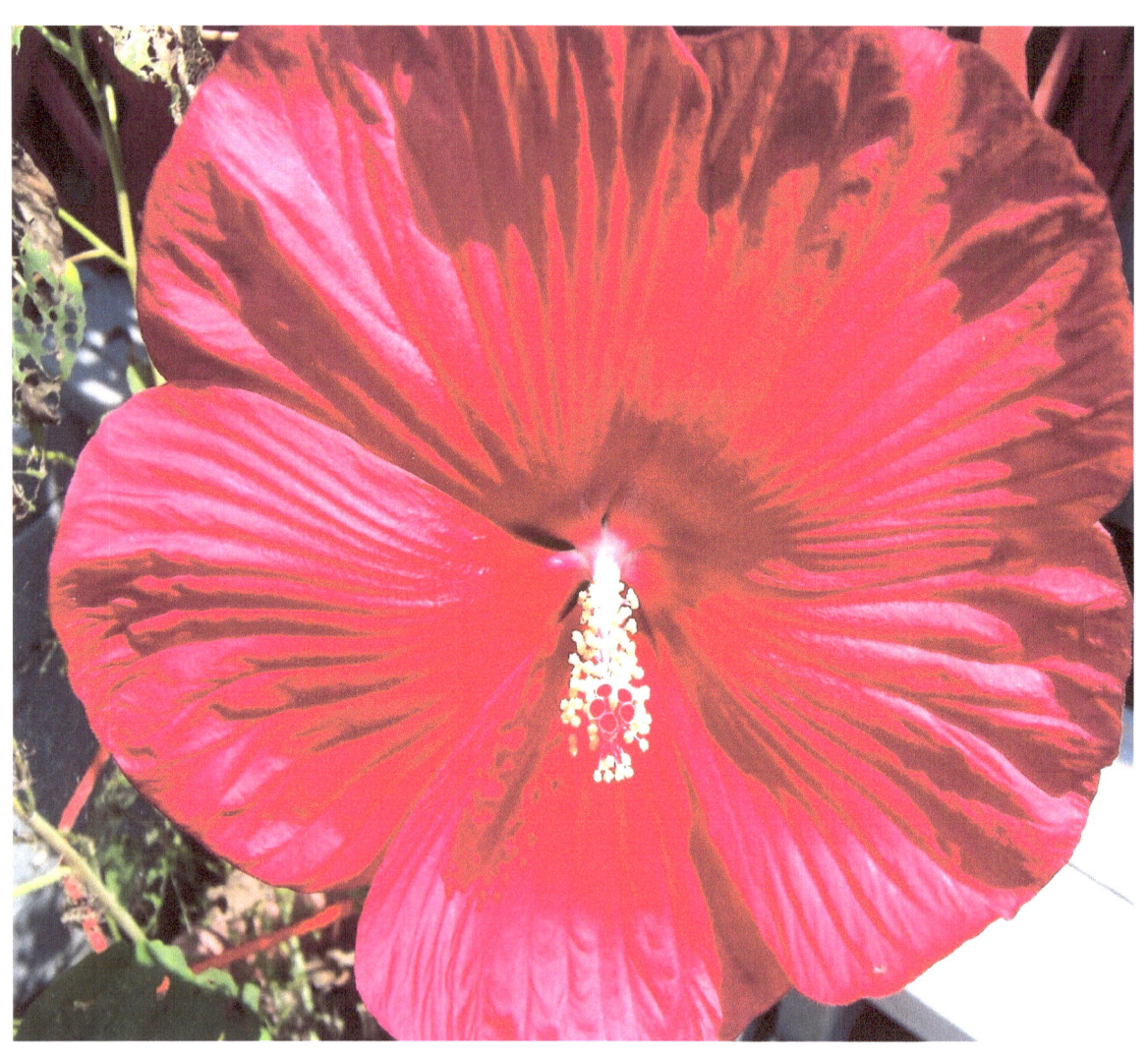

Big Red

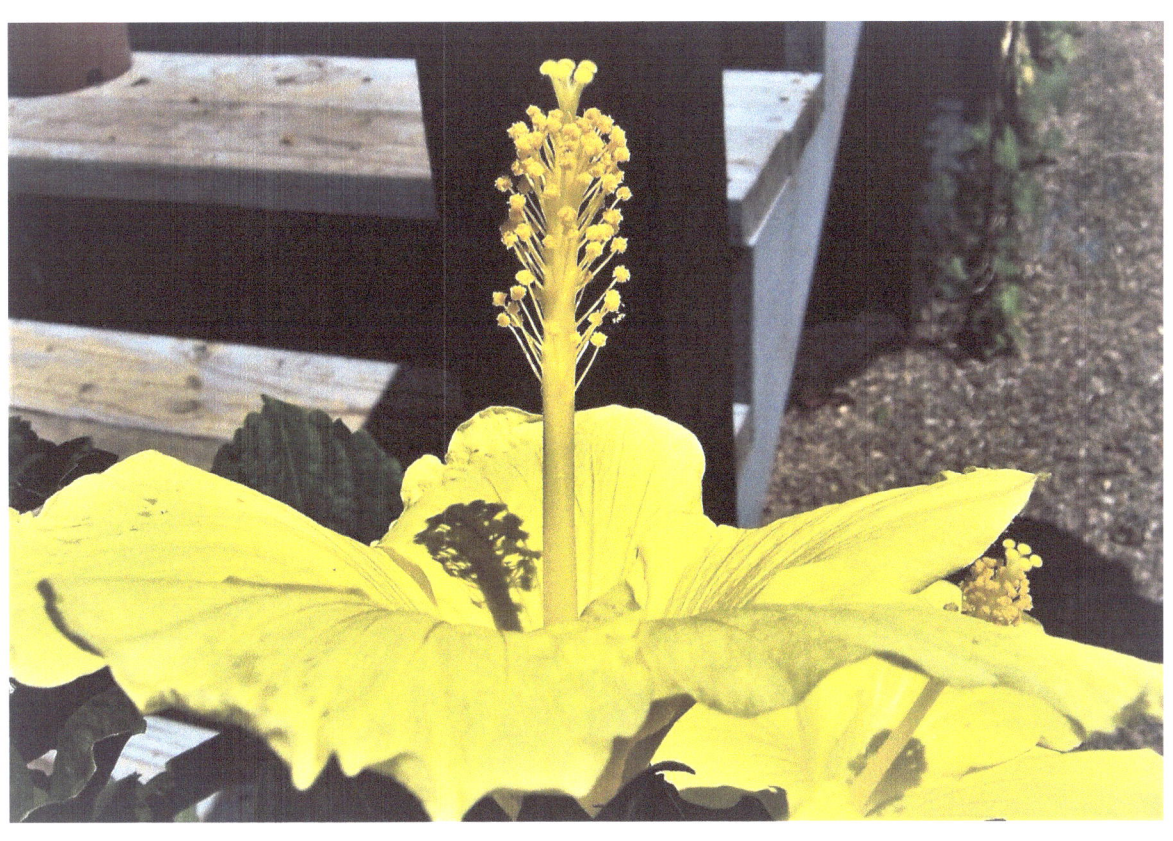

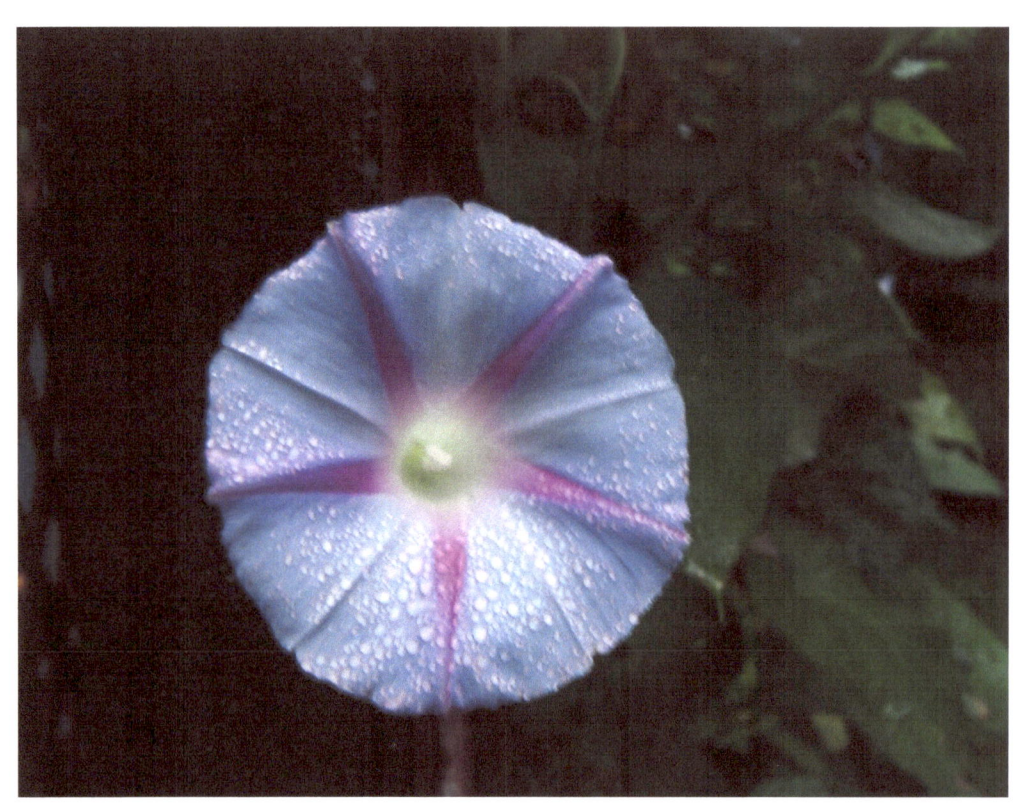

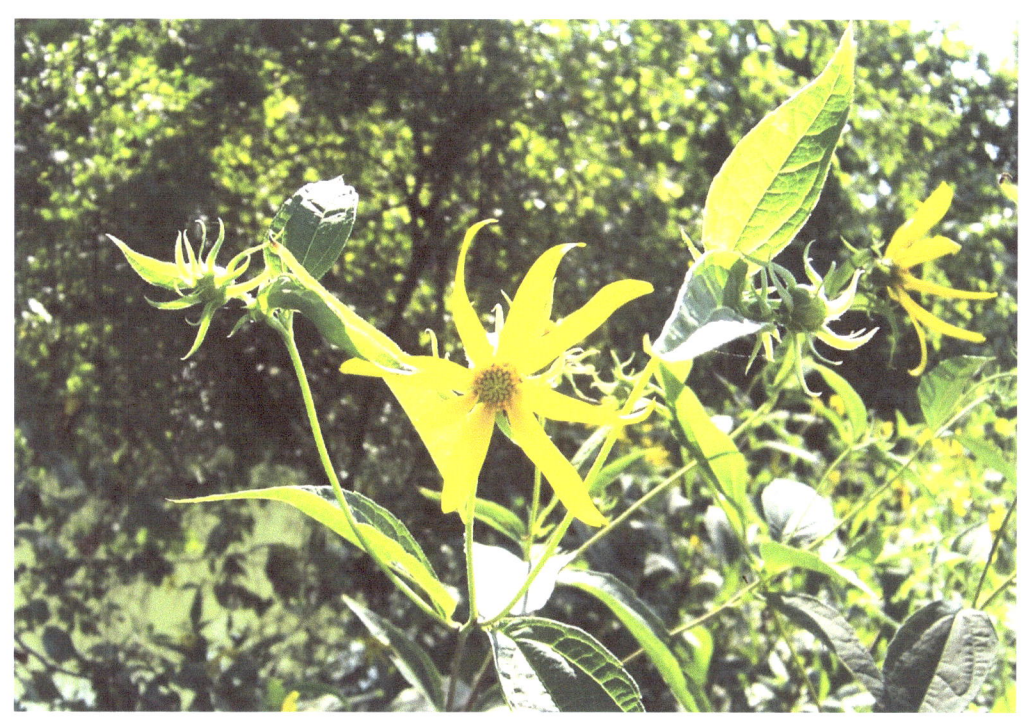

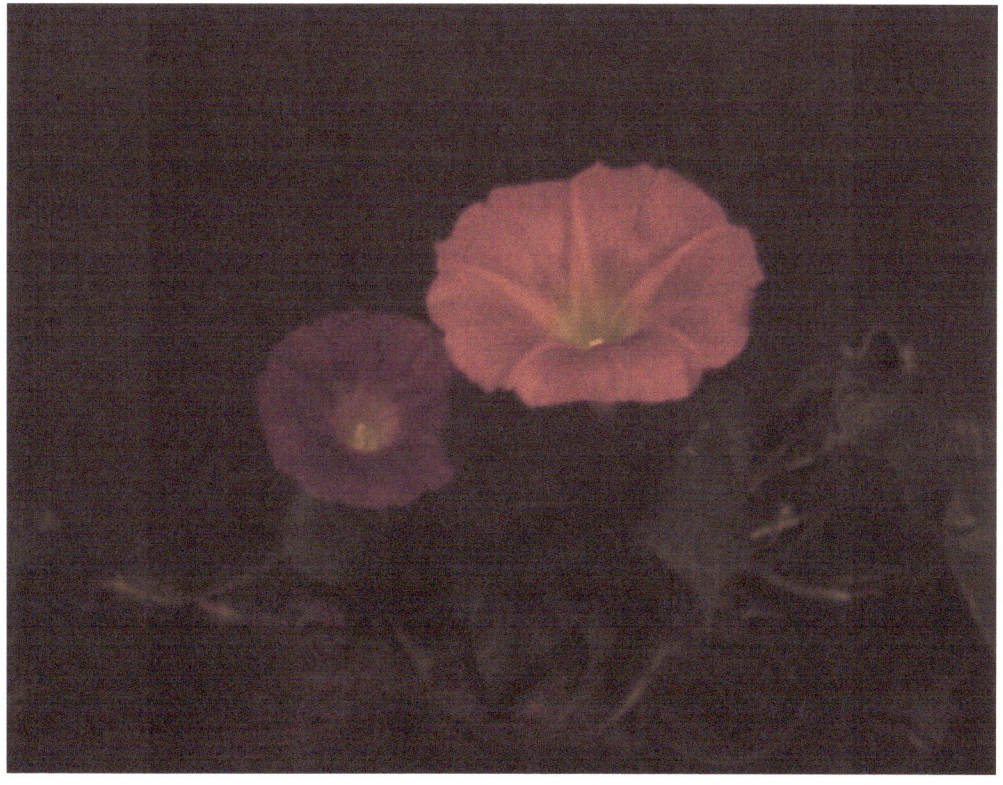

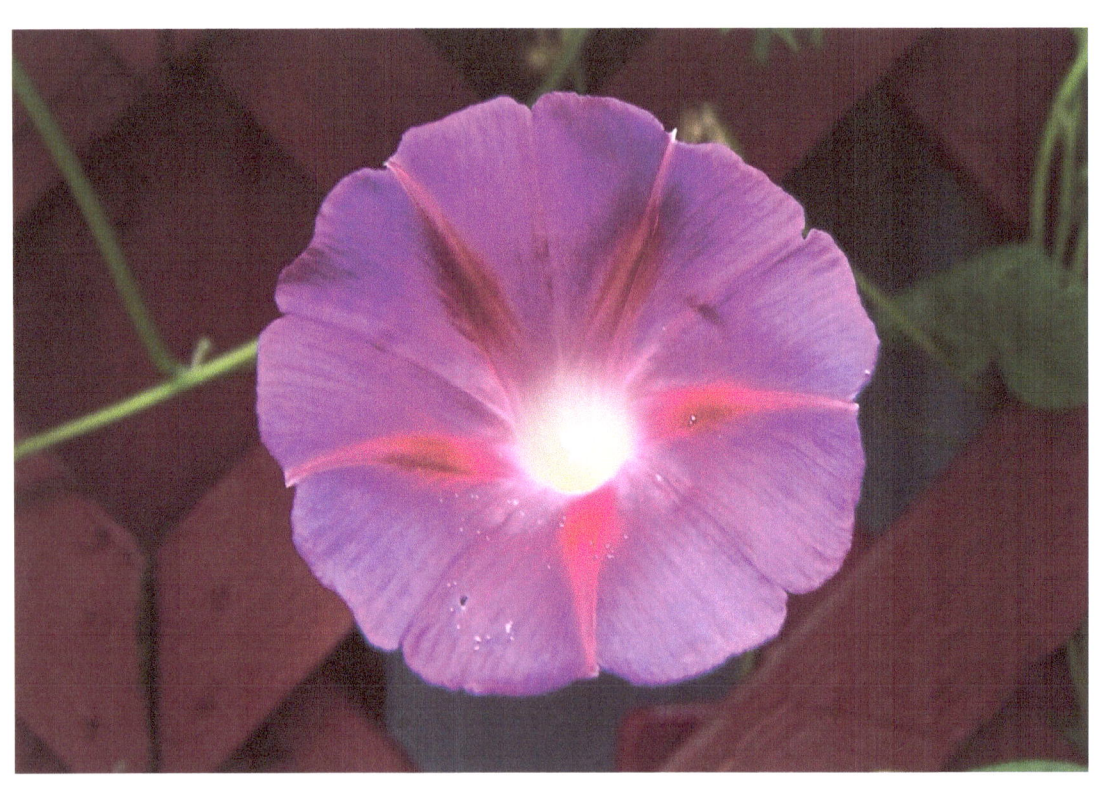

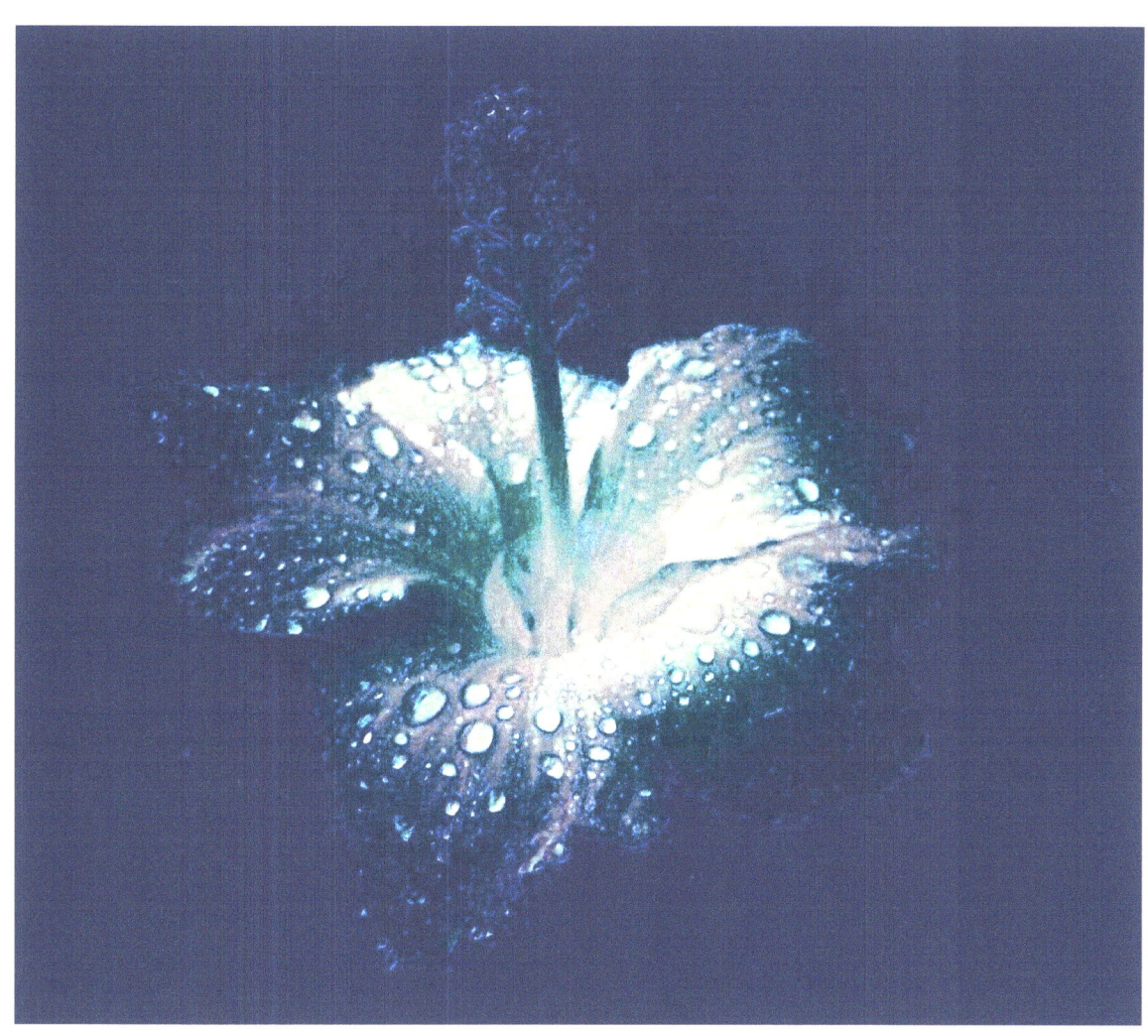

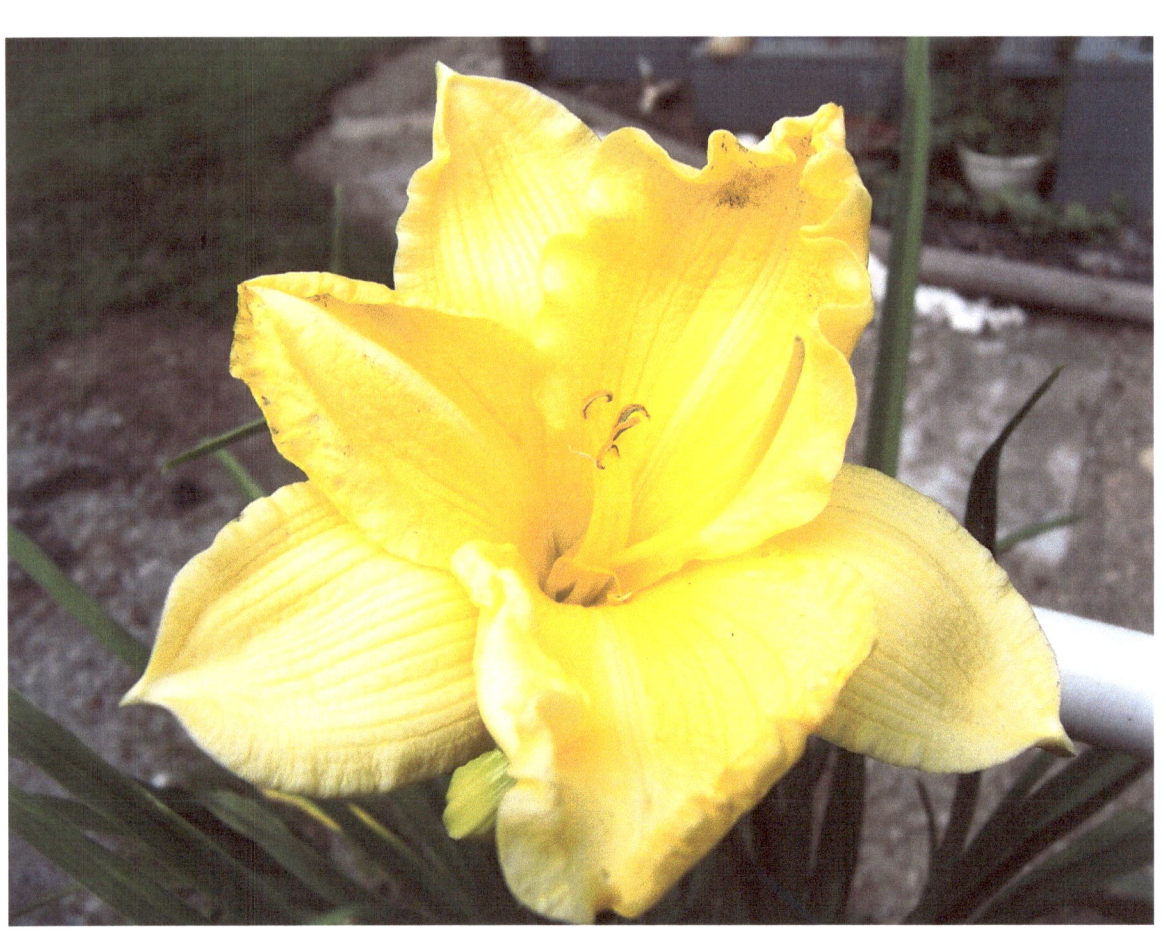

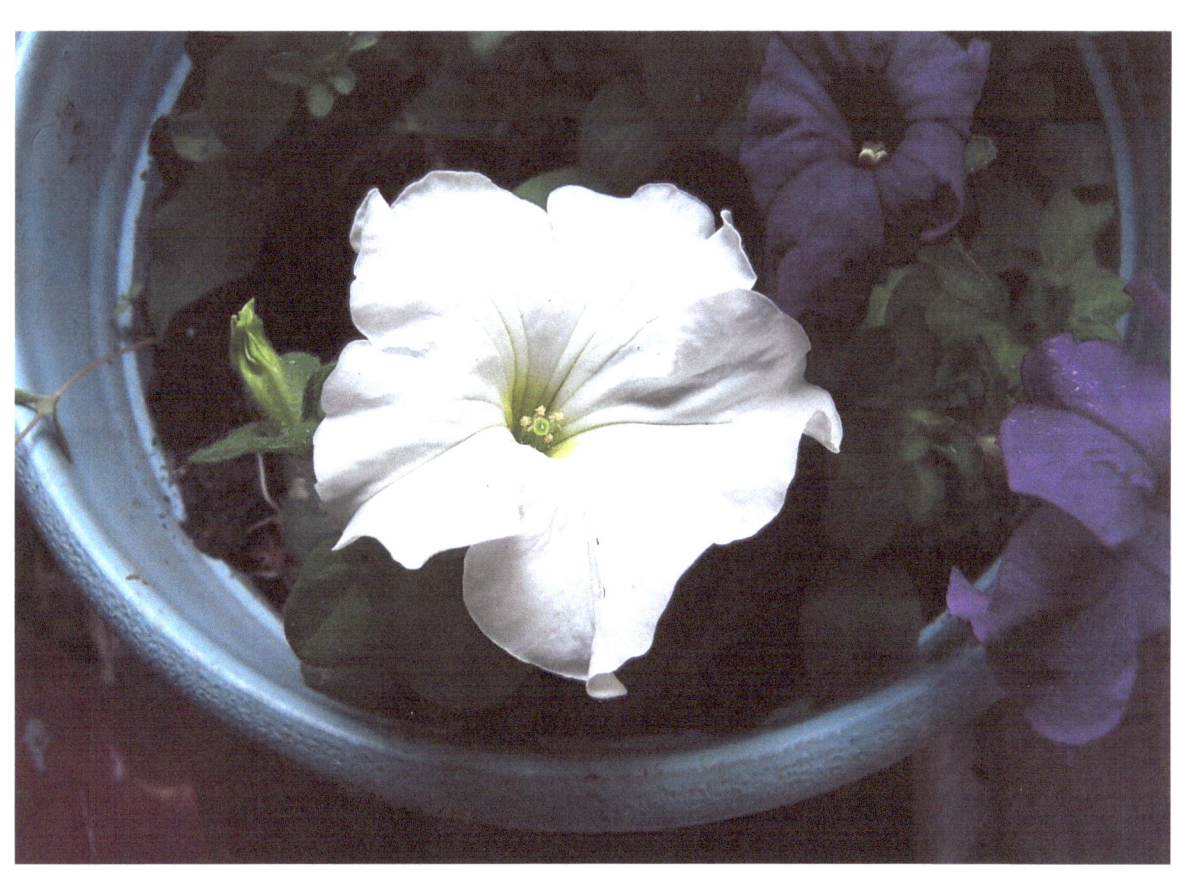

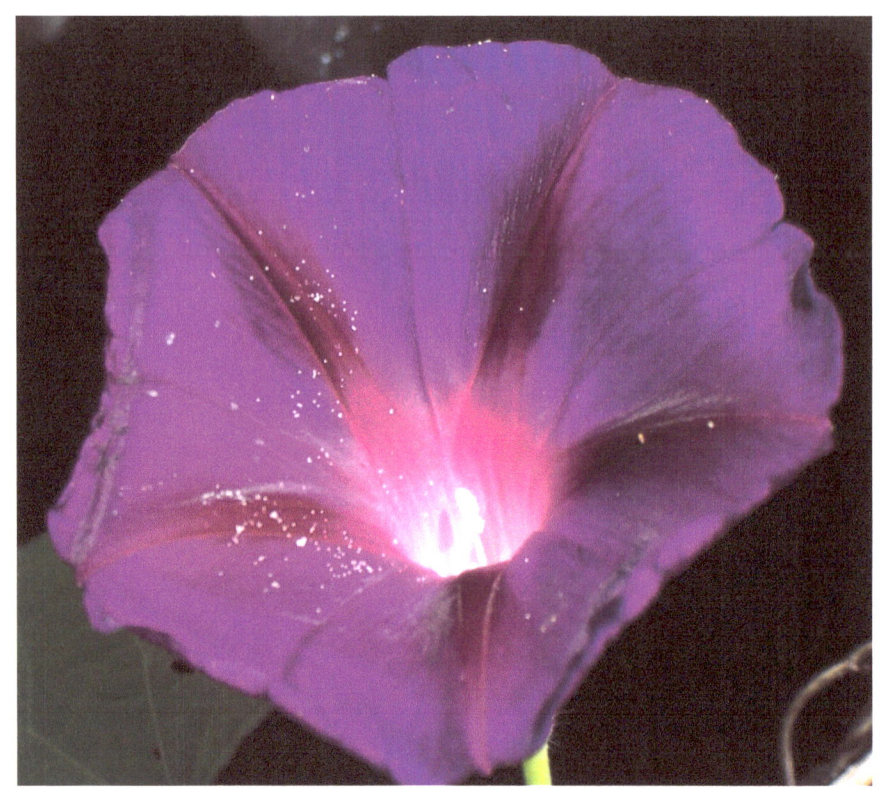

I never thought about it much
These wonders in my yard
Until one day it dawned on me
Their beauty is my reward
For stopping for a while
And gazing upon those beauties
Just to have the joy
As they sway in the breeze

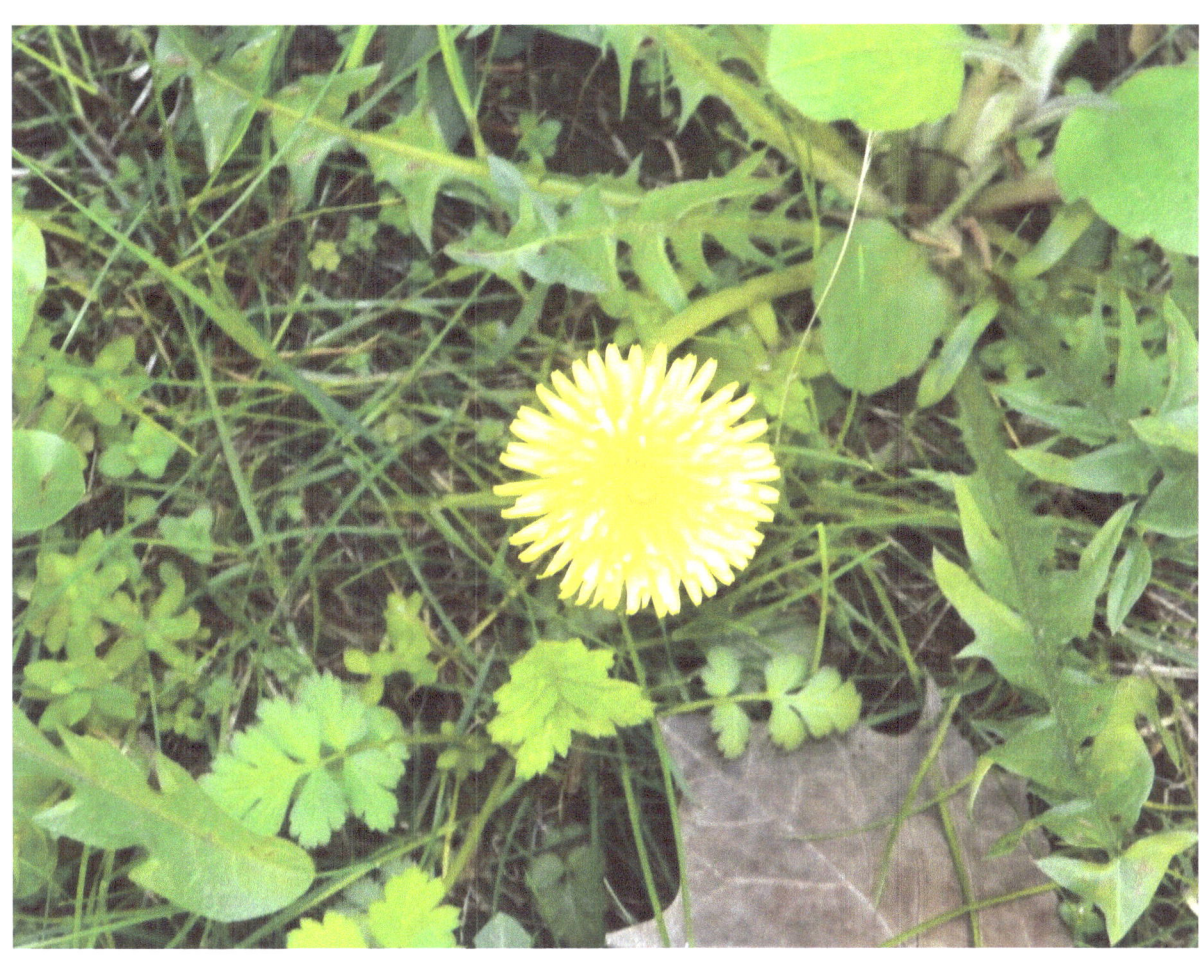

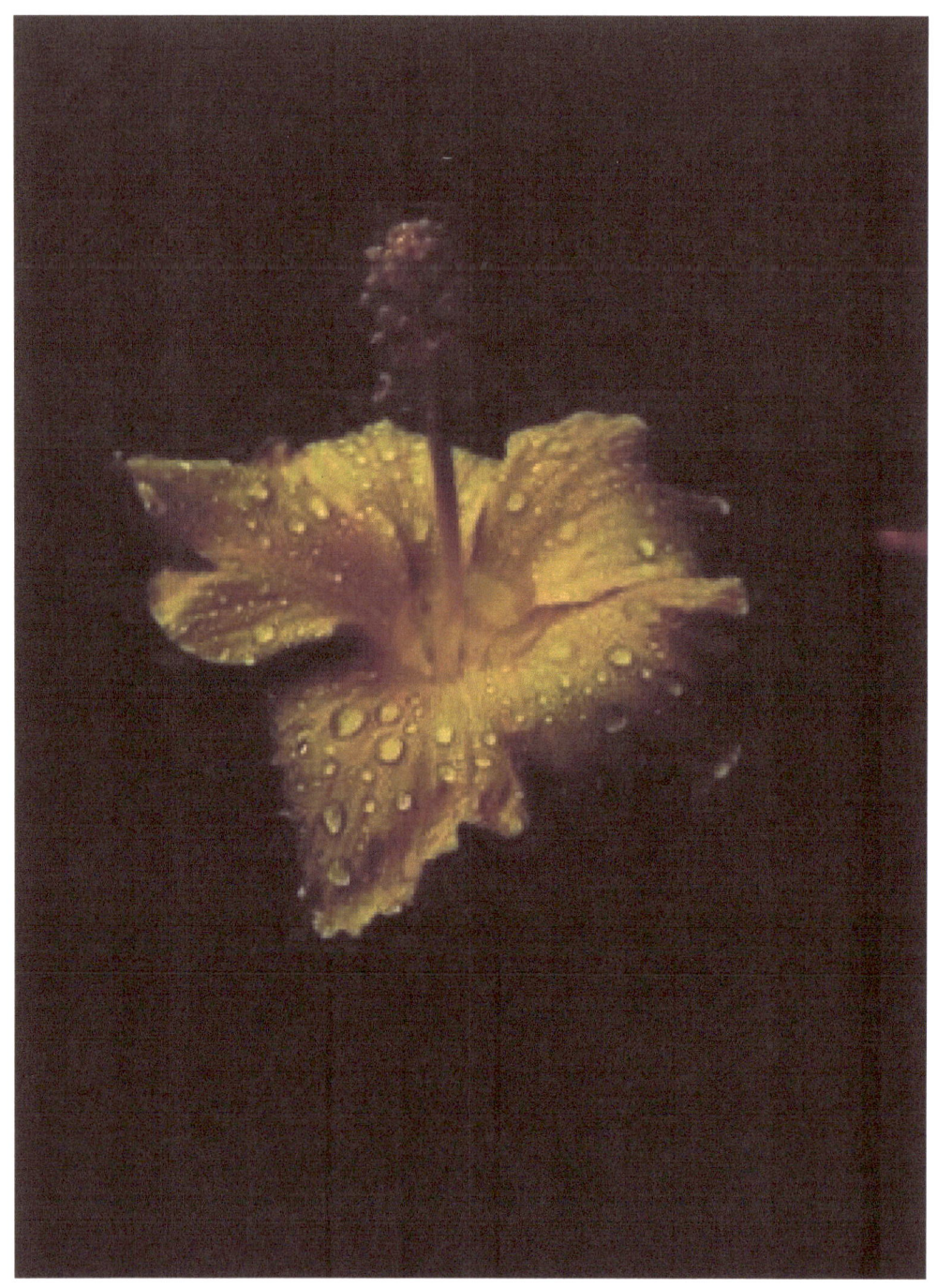

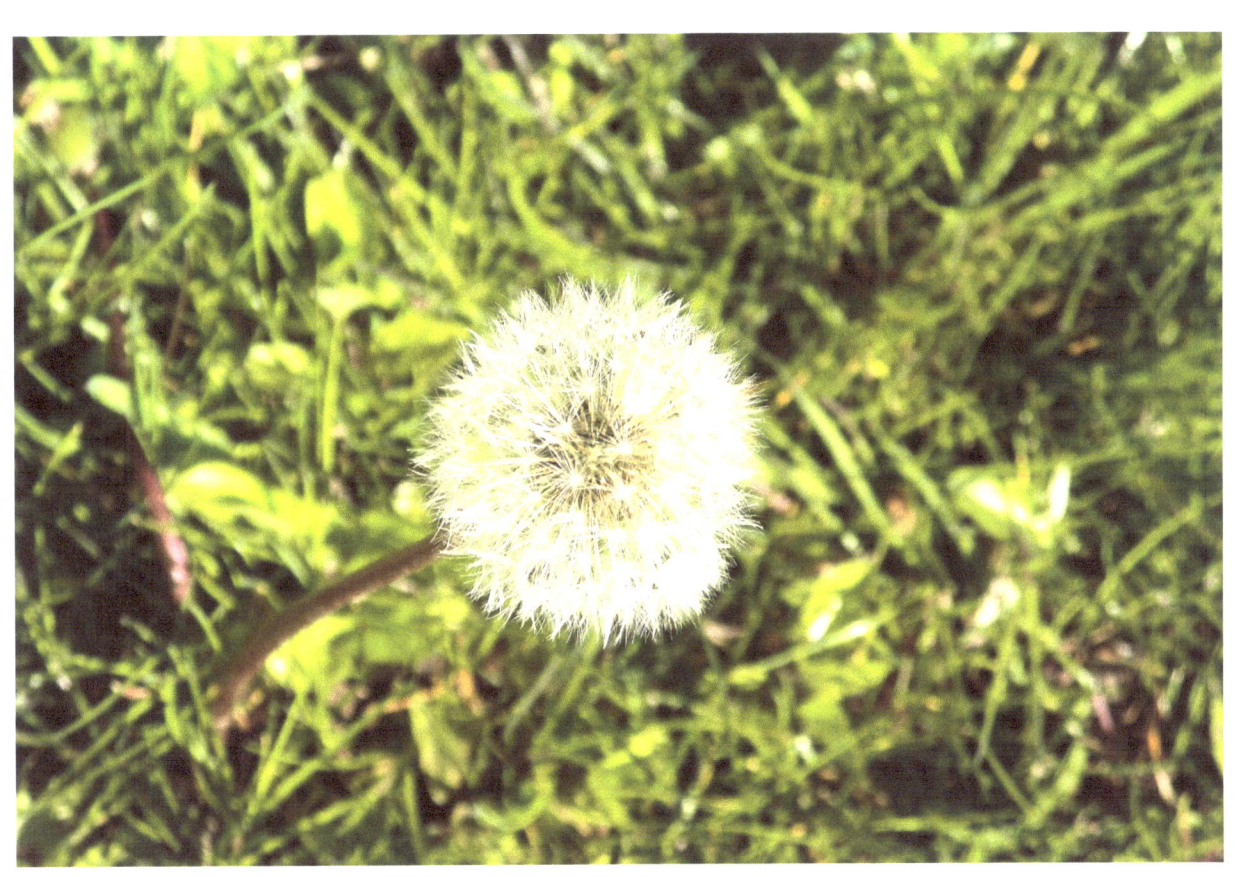

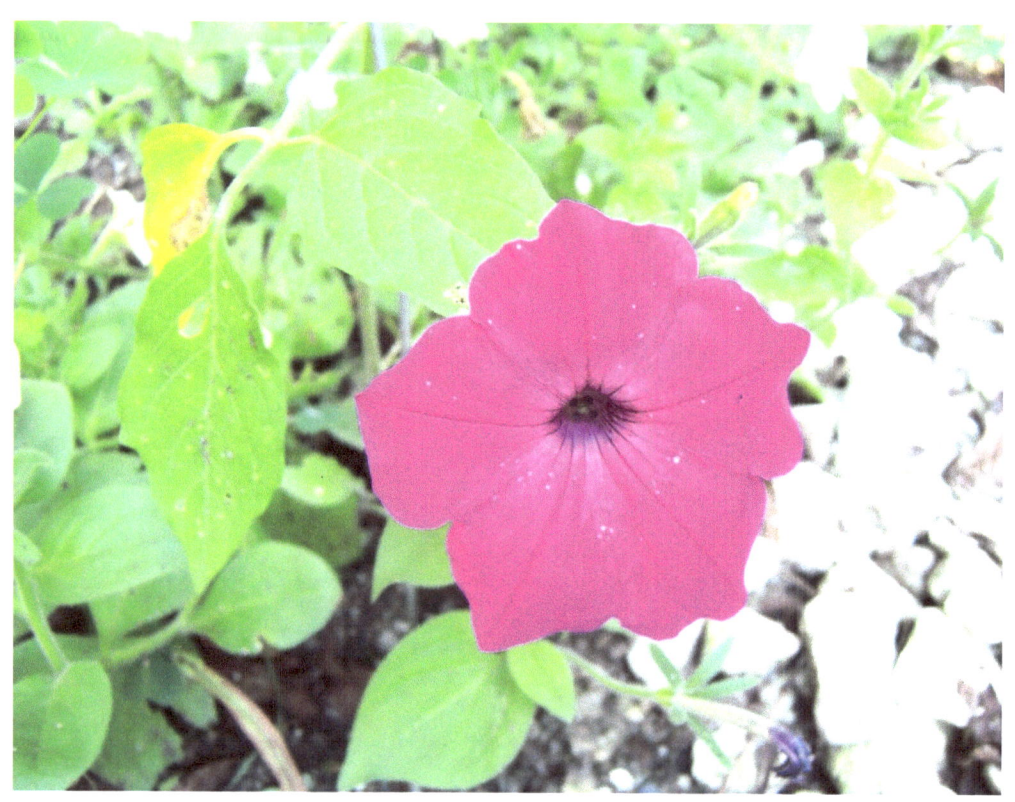

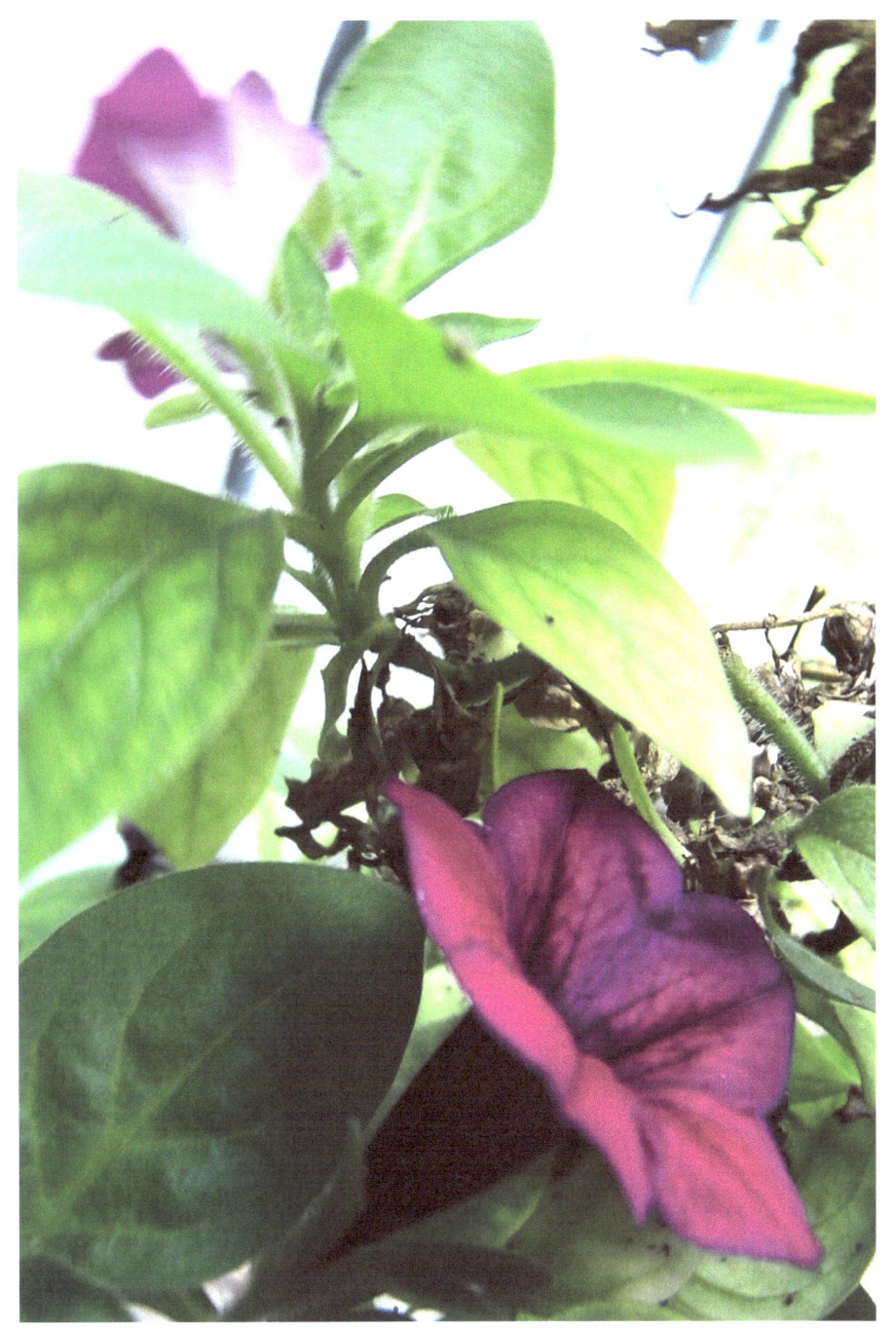

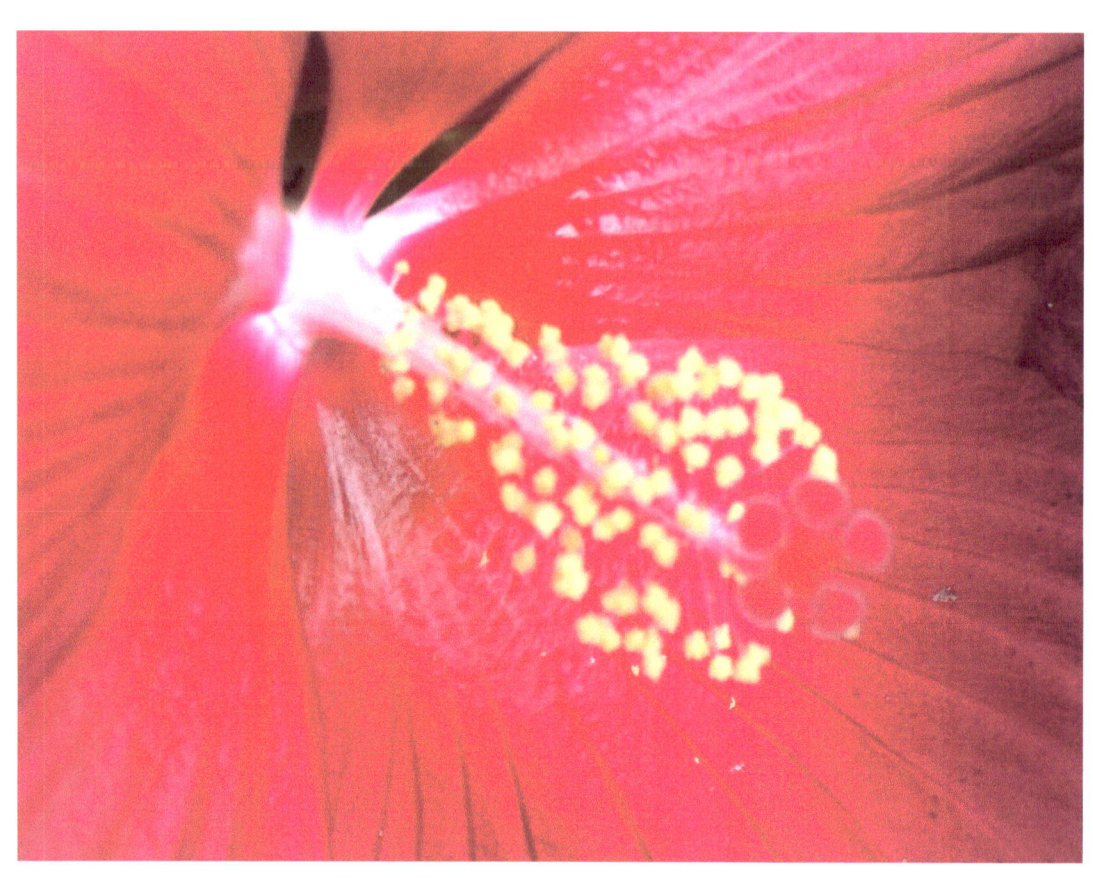

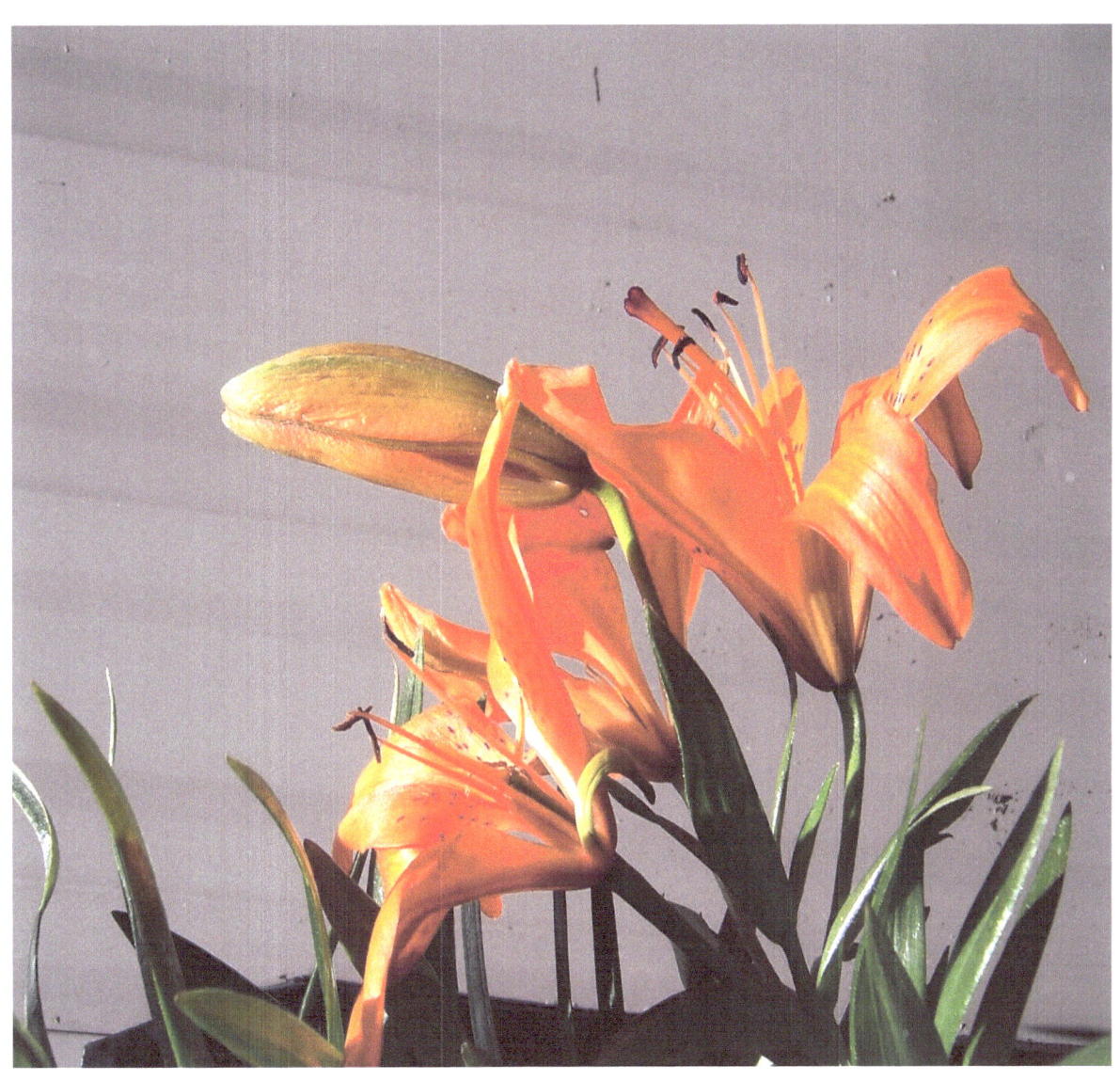

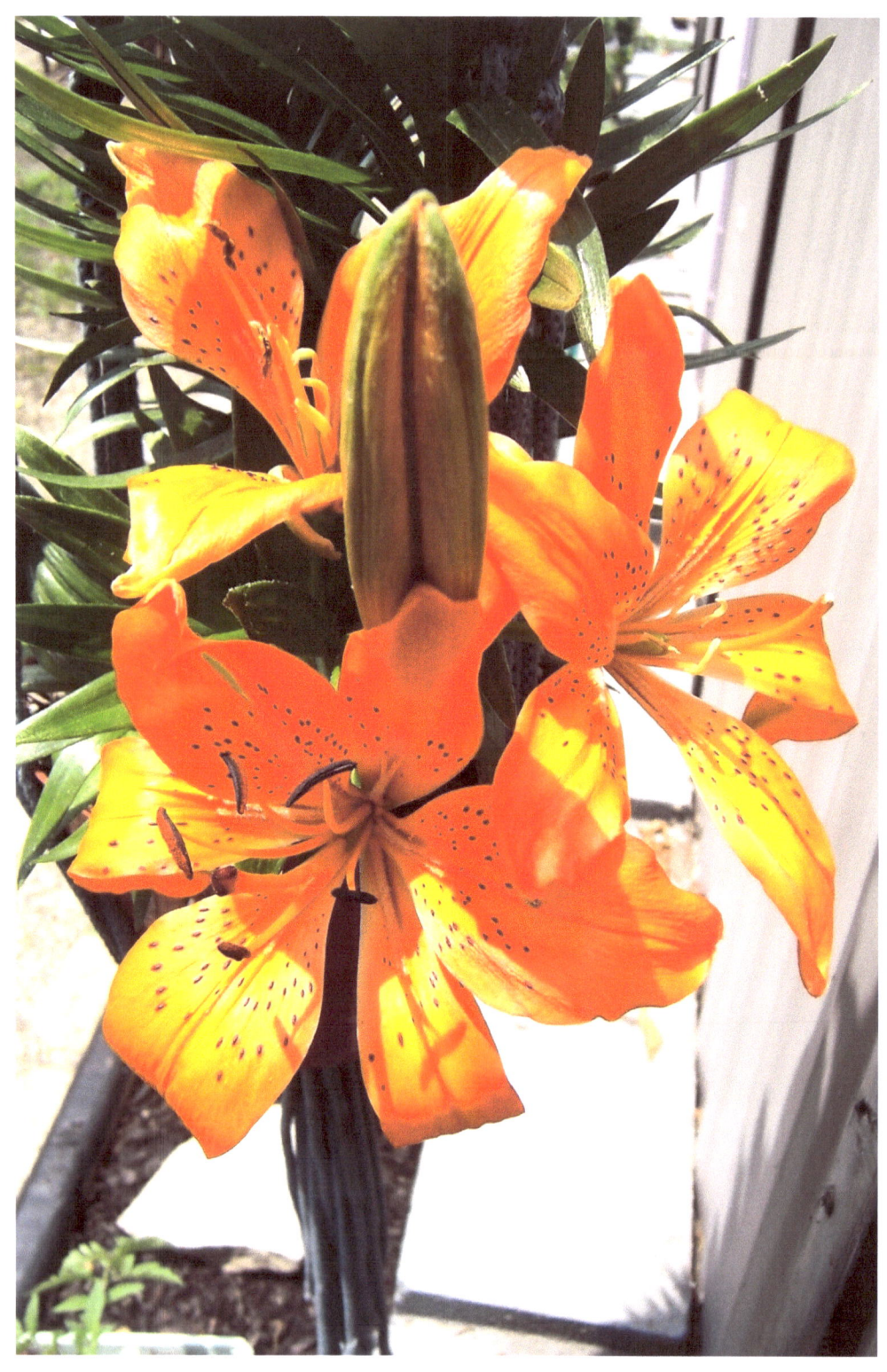

Note from the Author:

All images in this book are available for purchase as prints individually or as a complete set. For prices and print sizes available contact me through my website or any of my social media pages.

Please visit my official website at: http://www.deldemcclung.com

www.ingramcontent.com/pod-product-compliance
Lightning Source LLC
Chambersburg PA
CBHW051054180526
45172CB00002B/629